Writing Arabic

From Script to Type

Stefan F. Moginet

The American University in Cairo Press

Cairo New York

First published in 2009 by
The American University in Cairo Press
113 Sharia Kasr el Aini, Cairo, Egypt
420 Fifth Avenue, New York, NY 10018
www.aucpress.com

First published in 2008 as *Du calame à l'ordinateur, l'évolution graphique de l'écriture arabe*
Copyright © 2008, 2009 by Adverbum. Work coedited with Centre de Conservation du Livre, Arles (France).

This English-language edition published by arrangement with Adverbum.
Translated from the French by Krystyna Horko

Dar el Kutub No. 4101/09
ISBN 978 977 416 292 3

Dar el Kutub Cataloging-in-Publication Data

Moginet Stefan
 Writing Arabic : From Script to Type / Stefan Moginet.—Cairo: The American University in Cairo Press, 2009
 p.112, 16 x 23 cm.
 ISBN 978 977 416 292 3
 1. Arabic language—writing I. Title
 492.7

Printed in Italy

Contents

Preface

I wrote the first draft of this book in 1983 when I was working in Morocco. My job consisted, among other things, of training draftsmen in Arabic lettering for printing.

I decided then that it would be a good idea to give my students a history of Arabic writing. That was when I discovered, to my surprise, that there were many books on calligraphy, but none of them clearly detailed the evolution of the various types of Arabic script.

Moreover, most authors preferred to discuss the esthetic and decorative aspects of calligraphy without touching on the principal function of writing itself, which is, after all, a vital means for communicating and transmitting knowledge. Lastly, the problems of using Arabic script in printing were never broached at all.

That is why I decided to present the various styles of Arabic writing in historical order of appearance, taking into account the materials and writing instruments that were used, as well as the complex encounter between the written script and printing—and later with computing.

This book is for anyone who is curious about the extraordinary history of writing around the world, but it is also for graphic artists, calligraphers, and plastic artists. I hope it will help them to make the appropriate choices among existing styles and provide them with a logical foundation for the creation of new logos and typefaces.

Stefan F. Moginet

The Origins of the Arabic Alphabet

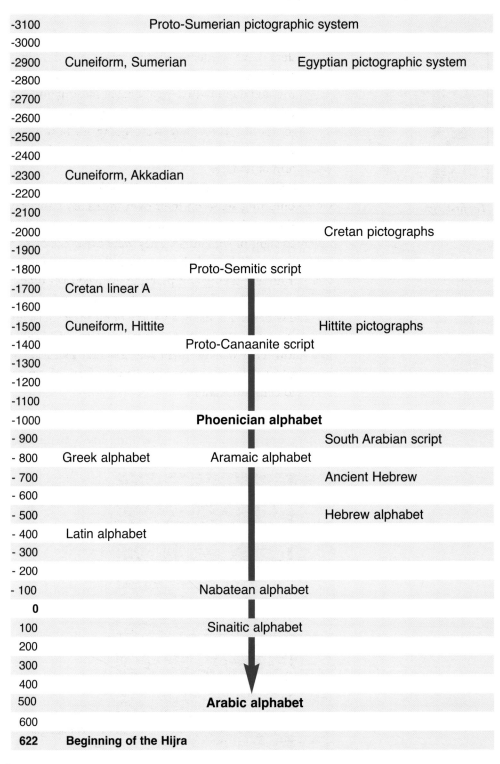

-3100	Proto-Sumerian pictographic system	
-3000		
-2900	Cuneiform, Sumerian	Egyptian pictographic system
-2800		
-2700		
-2600		
-2500		
-2400		
-2300	Cuneiform, Akkadian	
-2200		
-2100		
-2000		Cretan pictographs
-1900		
-1800	Proto-Semitic script	
-1700	Cretan linear A	
-1600		
-1500	Cuneiform, Hittite	Hittite pictographs
-1400	Proto-Canaanite script	
-1300		
-1200		
-1100		
-1000	**Phoenician alphabet**	
- 900		South Arabian script
- 800	Greek alphabet · Aramaic alphabet	
- 700		Ancient Hebrew
- 600		
- 500		Hebrew alphabet
- 400	Latin alphabet	
- 300		
- 200		
- 100	Nabatean alphabet	
0		
100	Sinaitic alphabet	
200		
300		
400		
500	**Arabic alphabet**	
600		
622	**Beginning of the Hijra**	

From Imprints
to Signs

The first sign.

Hunters have understood the language of animal tracks since the dawn of humanity. The trails left by their prey provided them with a great deal of information that was vital to their survival: the species type, their weight and age, the direction they were going in, how many animals there were, and so on. We can view this as an early form of *reading*.

By attributing meaning to animal tracks, early humans were conferring sense on their own tracks. By deliberately making prints of their hands or feet, people had invented signs or signatures. They were a mark of ownership, or a symbol. In their own way, these early people were printing. Etching and painting evolved over time.

The custom of marking places, objects, and individuals became widespread, using a variety of means such as fingers, pointed or sharp instruments, and colored matter like earth, charcoal, or plant and mineral extracts. By leaving traces, humanity acquired a new form of expression and communication.

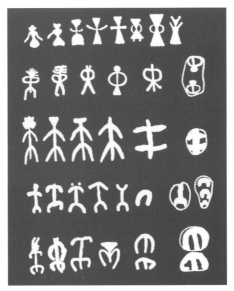

*Paleolithic signs
(Spain).*

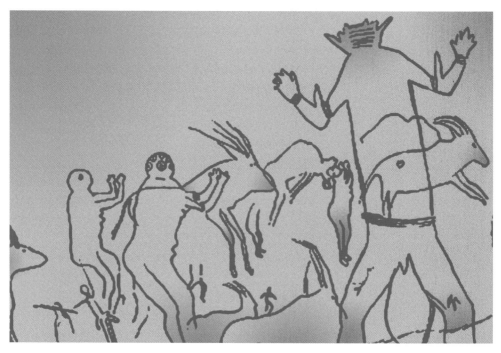

The first pictures: information and/or magic?
Cave paintings, Tassili (Algeria).

From Signs
to Drawings

G radually, the desire to represent reality transformed the primitive signs into drawing. Early humans considered the power to create images to be such an extraordinary activity that for a long time it was reserved for magic or religious practices. The first drawings were also the first artificial memories, and have transmitted information to us from those distant ancestors of ours.

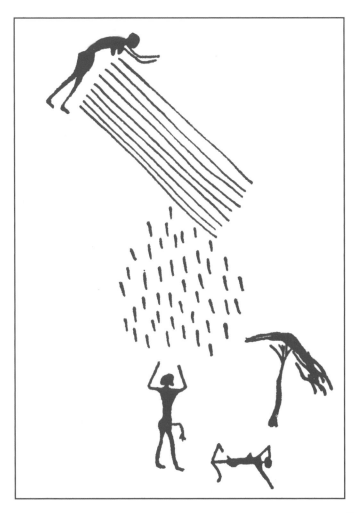

*Narrative image:
invoking rain?
(Zimbabwe).*

Sumerian clay tablet (Uruk).
Front: inventory; back: record of sheep and cows.

A damp clay tablet for cuneiform writing and a stylus (wooden awl with one pointed and one flat end). The holes were used for counting.

The development of pictographs: an ox.

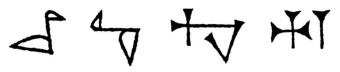

From pictograph to cuneiform sign: a bird.

From Signs
to Letters

The development of pastoral civilizations and the need to count herds and estimate wealth gave rise to the idea of fixing and transmitting information by means of marks and images.

Over time, these images became increasingly standardized and the original drawings evolved into symbol-drawings, or pictographs; but humankind was still a long way from phonetic transcriptions.

Representing a sound (rather than an object) by means of a sign was a gradual process that occurred along with the development of pictographs. The growing number of signs began to form codes that, although complex, transmitted fairly precise information.

By now we can call this *writing*, a phenomenon that emerged with the development of the first urban civilizations of Mesopotamia. The most ancient systems of writing we have found were used by the Sumerians 3,000 years before our era.

Two factors influenced the development of signs:
• the medium and tracing instrument used, which changed the shapes of the lines;
• the desire to reduce writing movement.

With the use of the clay tablet and stylus, the representational pictographs gradually evolved into abstract signs and formed the cuneiform writing that was to be used by many peoples, including the Elamites, Hittites, Assyrians, and Babylonians, etc.

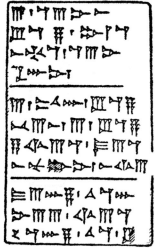

Ras Shamra tablet (Syria):
cuneiform text in the Ugarit language (1400 BCE).

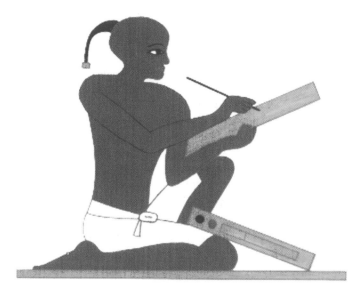

The scribe with his equipment:
papyrus, box of reed pens, and ink pots.

Carved monumental writing style: hieroglyphs.

Literary writing style: cursive hieratic (Twelfth Dynasty).

Official writing style: cursive hieratic (Twentieth Dynasty).

Everyday writing style: demotic cursive (300 BCE).

The Egyptians

It was the Egyptians who made the vital discovery of the stylus (a pen made from a sharpened reed), as well as ink and papyrus. It was thanks to papyrus, a very light material, easy to make and transport in Egypt, and which also kept very well, that writing developed in such spectacular fashion. For thousands of years papyrus was the medium on which thought was transcribed.

The smooth surface of the papyrus and the lightness of the reed pen had a considerable impact on the aspect of the writing itself. The shape of the writing became more rounded, and as a result was easier and faster to write. This gave rise to cursive writing styles that looked very different from carved or lapidary writing.

The Egyptians used a pictographic system and progressively added a phonetic dimension. The carvers, sculptors, and painters who transformed buildings into massive books that could be read also used a pictographic form of writing, namely hieroglyphs.

The scribes used cursive hieratic script for administration and official texts, which was similar to hieroglyphs and quite slow to produce. In everyday life they used demotic script, which evolved away from hieroglyphs to become non-figurative signs that allowed the writer to minimize hand movements by using more supple lines.

The development of signs in Egyptian writing.

	Hieroglyph						Hieratic			Demotic

| Years BCE | 2900 | 2600 | 2000 | 1500 | 500 | 1500 | 1900 | 1300 | 200 | 100 |

The stela of Mesha, King of Moab, bears an inscription in Moabite, which is close to ancient Phoenician. It commemorates his victory over the Kings of Israel (circa 800 BCE).

Phoenician inscription on papyrus (Cyprus, 1000 BCE).

The Phoenicians

For centuries, different forms of writing came and went. They were based on pictographic systems that, to varying degrees, were combined with syllabic ones.

The idea of representing sounds with a limited number of signs, the combination of which make it possible to transcribe words and phases phonetically, is attributed to the Phoenicians.

In this way the alphabet was born, although at this stage it was made up only of consonants.

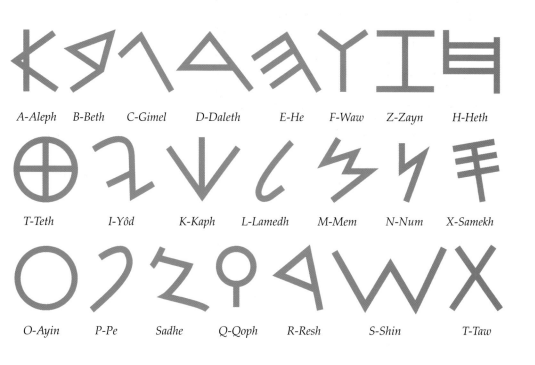

A-Aleph B-Beth C-Gimel D-Daleth E-He F-Waw Z-Zayn H-Heth

T-Teth I-Yôd K-Kaph L-Lamedh M-Mem N-Num X-Samekh

O-Ayin P-Pe Sadhe Q-Qoph R-Resh S-Shin T-Taw

Comparative Table of the Major Semitic Scripts

Phoenician	Palestinian	Aramaic	Hebrew	Syriac	South Arabian	Arabic
𐤀	𐤀	𐤀	א	ܐ	𐩱	ا
𐤁	𐤁	𐤁	ב	ܒ	𐩨	ب
𐤂	𐤂	𐤂	ג	ܓ	𐩴	ج
𐤃	𐤃	𐤃	ד	ܕ	𐩵	د
					𐩠	ذ
𐤄	𐤄	𐤄	ה	ܗ	𐩢	ه
𐤅	𐤅	𐤅		ܘ	𐩥	و
𐤆	𐤆	𐤆		ܙ	𐩹	ز
𐤇	𐤇	𐤇	ח	ܚ	𐩭	ح
𐤈	𐤈	𐤈	ט	ܛ	𐩰	خ
					𐩼	ط
𐤉	𐤉	𐤉	י	ܝ	𐩠	ظ
𐤊	𐤊	𐤊	כ	ܟ	𐩫	ك
𐤋	𐤋	𐤋	ל	ܠ	𐩡	ل
𐤌	𐤌	𐤌	ם	ܡ		م
𐤍	𐤍	𐤍	ן	ܢ	𐩬	ن
𐤎	𐤎	𐤎	ס	ܣ	𐩯	ن
𐤏	𐤏	𐤏	ע	ܥ	𐩲	ع
					𐩶	غ
𐤐	𐤐	𐤐	ף	ܦ	𐩰	ف
𐤑	𐤑	𐤑	ץ	ܨ	𐩮	ض
					𐩳	ض
𐤒	𐤒	𐤒	ק	ܩ	𐩤	ق
𐤓	𐤓	𐤓	ר	ܪ	𐩧	ر
			ש	ܫ	𐩦	س
𐤔	𐤔	𐤔	ש	ܫ	𐩪	ش
𐤕	𐤕	𐤕	ת	ܬ	𐩩	ت

The advantages of the Phoenician script were such that it prevailed over all the others and gave rise to all the major Semitic and European forms of writing, including Canaanite, Aramaic, Hebrew, Arabic, Greek, and Latin.

Some of the precursors of the Arabic script:

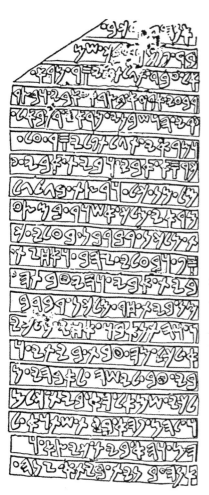

Estrangelo (Syria, fifth century).

Aramaic inscription of Barrakid at Zincirli (900 BCE).

South Arabian inscription.

17

Traditional Arabic letters

ا	ا	ا	ا	alif
ب	ب	بـ	بـ	ba'
ت	ت	تـ	تـ	ta'
ث	ث	ثـ	ثـ	tha'
ج	ج	جـ	جـ	jim
ح	ح	حـ	حـ	ha'
خ	خ	خـ	خـ	kha'
د	د	د	د	dal
ذ	ذ	ذ	ذ	dhal
ر	ر	ر	ر	ra'
ز	ز	ز	ز	zayn
س	س	سـ	سـ	sin
ش	ش	شـ	شـ	shin
ص	ص	صـ	صـ	sad
ض	ض	ضـ	ضـ	dad
ط	ط	ط	ط	ta'
ظ	ظ	ظ	ظ	za'
ع	ع	عـ	عـ	'ayn
غ	غ	غـ	غـ	ghayn
ف	ف	فـ	فـ	fa'
ق	ق	قـ	قـ	qaf
ك	ك	كـ	كـ	kaf
ل	ل	لـ	لـ	lam
م	م	مـ	مـ	mim
ن	ن	نـ	نـ	nun
ه	ه	هـ	هـ	ha'
و	و	و	و	waw
ي	ي	يـ	يـ	ya'
ء	ء			hamza
ى	ى			alif maqsura
ة	ة			ta' marbuta

Ways of writing the hamza

أ	أ	أ	أ
إ	إ	إ	إ
آ	آ	آ	آ
ؤ	ؤ	ؤ	ؤ
		ئ	ئ
	ئ	ئ	

و	وو		´
3		´ 2	1
´		´	°
5		4	

Vowel signs
1- fatha (a)
2- kasra (i)
3- damma (o)
4- sukun
5- shadda

The Arabic Alphabet

Arabic writing is read from right to left.

- It is consonantal and the alphabet has 29 consonants (28 plus the hamza).
- Some letters are joined to the preceding or subsequent ones. Some are never joined to the subsequent ones.
- Each letter has between two and four different forms, depending on where it is situated in the word.

4 3 2 1

1: initial (at the beginning of the word),
2: medial (in the middle of the word),
3: final (at the end of the word),
4: isolated.

- Vowels are indicated by means of signs placed above or below the consonants.

Certain similarly shaped letters are differentiated by the number of dots placed above or below the letter.

Certain combinations of letters are written in special shapes called ligatures.

The Arabic alphabet does not have capital letters.

Note that the examples and tables in Arabic on the following pages should, of course, be read from right to left.

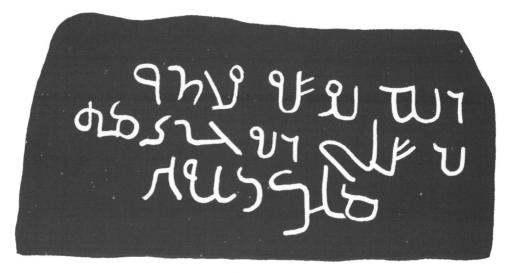

Nabatean stone inscription from Umm al-Jimal (Jordan, circa 250 CE).

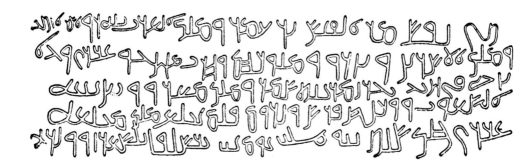

Tomb of the poet Imru' al-Qays (Namara, 328 CE).

Arabic inscription (Umm al-Jimal, sixth century).

Pre-Islamic
Writing

The first forms of Arabic writing grew out of the Semitic, Canaanite, Aramaic, and Nabatean writing systems with the emergence of the Arabic language. The letters that emerged around the fifth century (the Zabad inscription, dated 512 CE, or those in Harran from 568 CE and Umm al-Jimal in the sixth century) differed considerably from the Nabatean script. These distinct forms became the script we call North Arabian, because it was used in northeastern Arabia and gradually spread among the Arab tribes who lived in Hira and 'Anbar, and then Hejaz in Western Arabia.

Oral transmission still dominated during this period, and the use of writing was restricted to a few tombstones or commemorative inscriptions. Any other writing materials that may have been used at the time, such as leather, bone, or wood, have not survived.

The primitive Arabic script was also influenced graphically by Estrangelo, a form of Syriac writing that was in used in the fifth and sixth centuries CE. The oldest Arabic script is called *jazm*, and as it developed it became the writing of all the Arab people.

At that time, every town had a local derivative of jazm: *'anbari* in 'Anbar, *hiri* in Hira, *makki* in Mecca, and so forth, but they did not differ substantially. There were also three principal styles *mudawwar* (rounded), *muthallath* (triangular) and *ti'm* (twinned, meaning a combination of the other two).

Only two styles survived, one supple and cursive, called *mukawwar*, the other more angular, known as *mabsut*.

Arabic inscription (Harran, 568 CE).

Graffiti on a rock at Mount Sala, near Medina (circa 625 CE).

Letter showing cursive writing (early seventh century).

Stone inscription (677 CE).

Islamic Writing

After the death of the Prophet, the first concern of the scribes was to provide precise and faithful texts. This respect for the main function of writing, namely to transmit accurate information, would gradually lead to the development of simple and unambiguous styles.

However, there was still little difference between the carved (lapidary) shapes produced on hard materials such as stone, wood, or bone and the writing produced by a reed pen on a smooth medium such as leather, parchment, or papyrus.

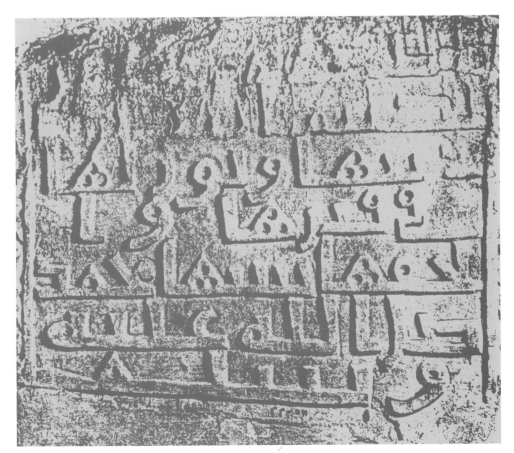

Relief inscription.

بسم الله الرحمن الرحيم
الله وحيد حسداوا
لحمد لله حسداوسبرا
لله بحره واصلا ولك
طوبك الله هم در
حسبرا و مبدرو اسر
قرا عمر لسك بربد
الا سلم ما محداه
دسه و ما بابر و لم قال
لا من رامر رب ا لعلمر

Inscription carved on the tomb of Thabet Ibn Yazid (628 CE).

بسم الله الرحمن الرحيم
لا اله الا الله وحده لا سسدك
لمحمد رسول الله امد بصسسه هد
السد كه كبد الله هساه ساه ساه ا
مسرا ململه الله علبد عمام د

Carved inscription (Iraq, 724 CE).

24

The First
Islamic Texts

Derived from *mukawwar*, the first Islamic texts used in Mecca and Medina were mainly written in *ma'il* (slanted style), *mashq* (extended style), and *naskh* (inscriptional style).

All other Arabic styles developed from the *mashq* and *naskh* styles of writing, divided into two groups, the angular and the cursive styles.

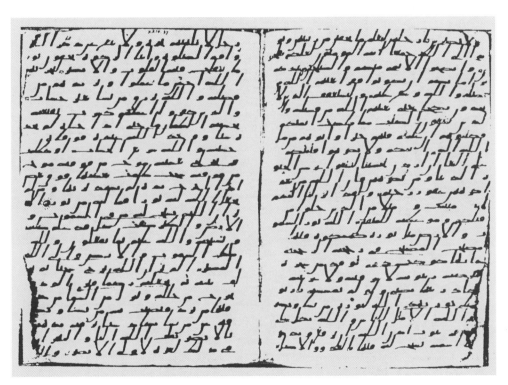

Ma'il writing used for one of the oldest copies of the Qur'an (Medina, eighth century).

Mashq writing, extract from the Qur'an (copied circa 715 CE).

Kufic writing without dots (Kairouan, eighth century).

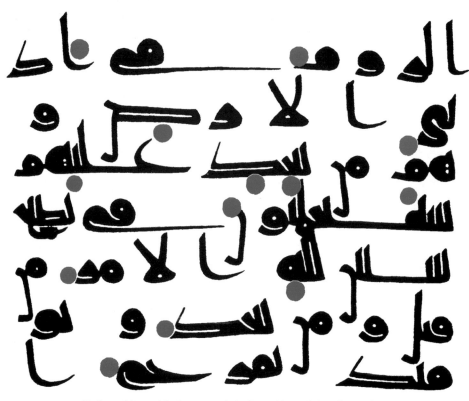

Kufic writing with short vowels indicated by red dots (752 CE).

After the Islamic conquest, the spread of reading through the Qur'an led to the creation of several seats of learning that required the services of numerous scribes. To ensure the integrity of the texts and the unity of writing, the learned scribes from the city of Kufa in Iraq disseminated and imposed their models of written copies of the Qur'an. These were the basic Kufic models, so by extension, all angular writing came to be called *Kufi* or Kufic.

Before the second century of the Hijra, the notation system was incomplete. The diacritical dots that made it possible to distinguish signs representing several letters were added by Nasr ibn 'Asim and Yahya ibn Mansour, and Abu-l-Aswad al-Duwali introduced red dots above or below the consonants to indicate short vowels.

This system was later abandoned in favor of indicating short vowels by means of specific signs called *harakat*, a system devised by al-Khalil ibn Ahmad al-Farahidi in the eighth century and still in use today.

Kufic script with occasional diacritical signs, Kairouan (ninth century CE).

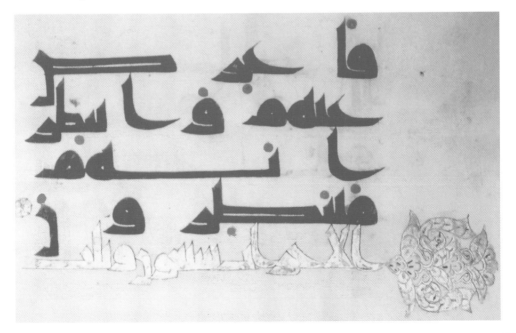

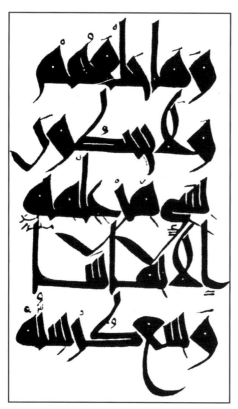

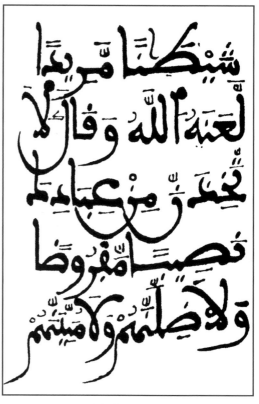

*Western Kufic script
(Kairouan, 1020 CE).*

*Maghribi script
(Morocco, eleventh century).*

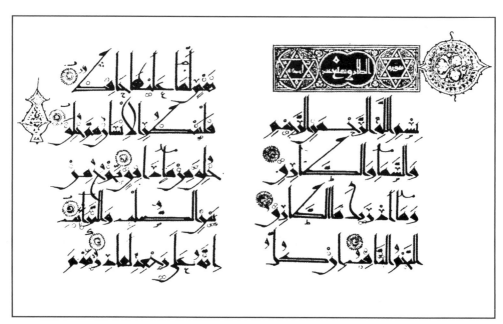

Eastern Kufic script with vowelization and diacritical dots (Persia, eleventh century).

Calligraphic Kufic

With improved techniques for cutting reed pens and the use of smoother, better prepared media such as parchment and vellum, the Kufic script rapidly evolved from its original crude form to become more refined, with contrasting full and slender strokes.

The Eastern Kufic script (Mashreq) looks as though the pen is impatient to break away from its severe geometric constraints to achieve a finer and suppler style of writing.

Copies of the Qur'an were adorned with decorative elements that in no way hindered the reading—on the contrary, they emphasized textual hierarchy by highlighting the titles of the surats and separating the verses. Originally, the introduction of colored inks was less for decorative than practical purposes, red, for instance, signaling short vowels and *tanwin*.

The *Maghribi* style was the culmination of the contrast between harsh right angles and the cursive tendencies of the reed pen.

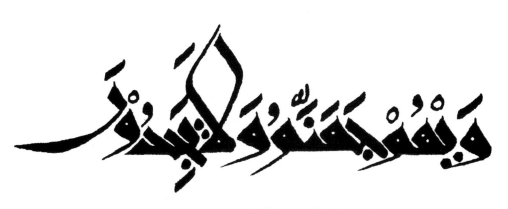

Eastern Kufic script with vowels, Khalil system (Persia, tenth century).

Maghribi script, Fez.

Maghribi script, Fez.

The Maghribi Style

During the tenth century in the western part of the Muslim empire, which included North Africa and Spain, the Kufic script became even more rounded and gave way to a truly cursive style known as *Maghribi*.

While retaining a horizontal line of writing and large perpendicular vertical strokes, the *Maghribi* style made full use of curves, especially in the last letters of words, which reached down to touch or intertwine with the following words.

These descending curves served to balance out the space between the lines. Note also the curved extremities of the strokes, thanks to the special cut of the reed pen.

There were several local and individual variations of the *Maghribi* style.

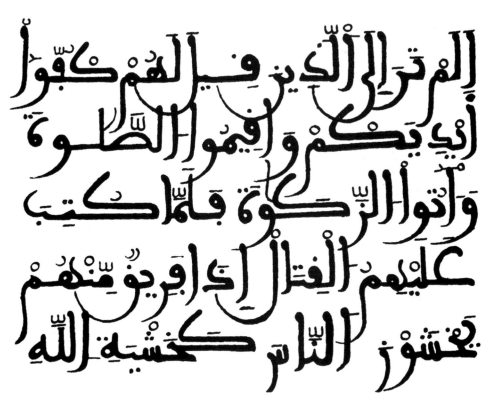

Maghribi script, Karajan.

'Knowledge tastes bitter at first, but sweeter than honey at the end.'
Kufic calligraphy on a plate (Nishapur, tenth century).

Lapidary
Kufic

As Arab civilization flourished in the tenth century, a variety of artistic activities developed, including architecture and decoration. Written verses from the Qur'an became a dominant part of mural decoration, both inside and outside.

The stonecutter's chisel accentuated the geometrical shapes of the Kufic style. The technical constraints of triangular cuts at the extremities of vertical strokes (the equivalent of serifs in Latin letters) were transformed into variable decorative elements, not only in engraved or carved texts, but also in calligraphic ones.

The development of decorative endings.

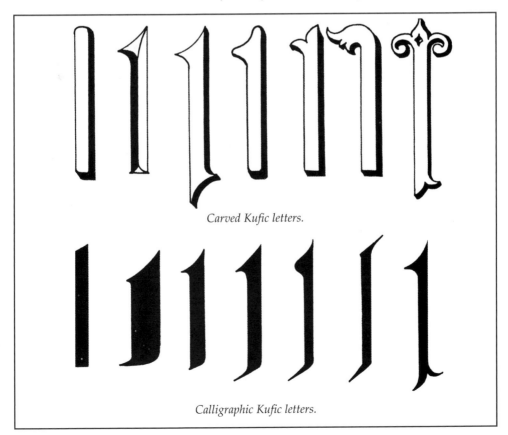

Carved Kufic letters.

Calligraphic Kufic letters.

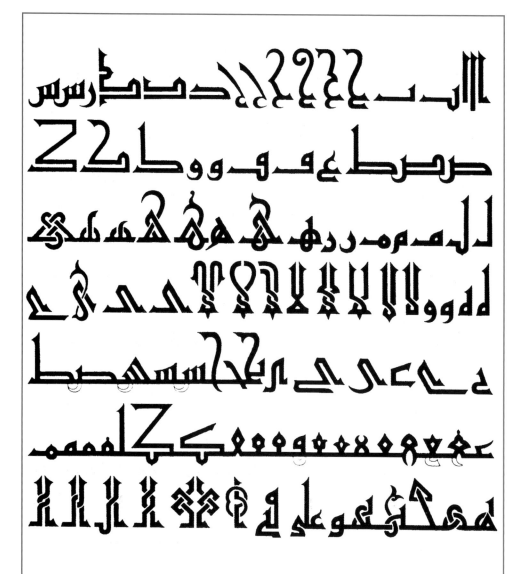

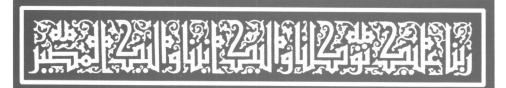

Classic Kufic (Iraq, twelfth century).

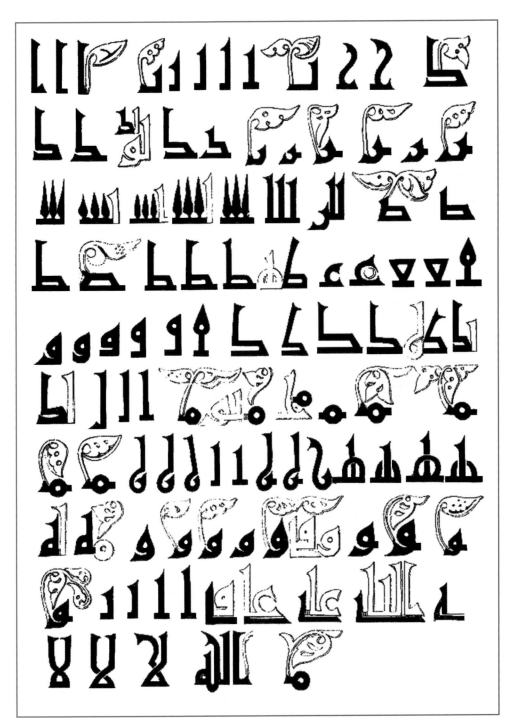

Classic Kufic with floriated endings (Fatimid Dynasty).

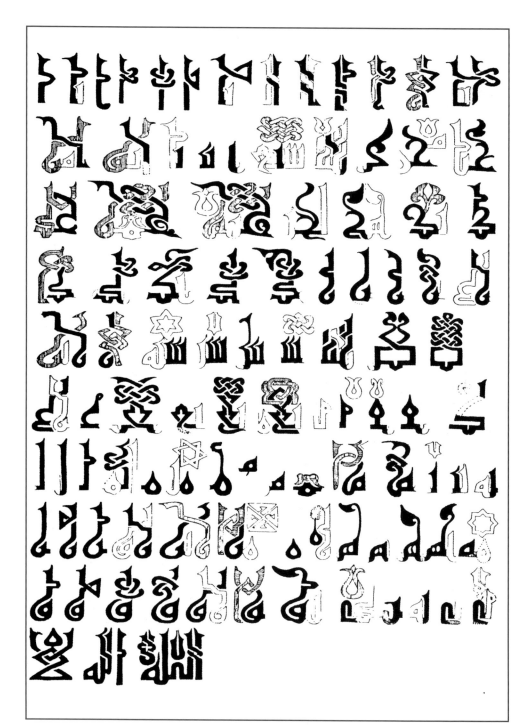

Carved Kufic with intertwined endings (Iraq, twelfth century).

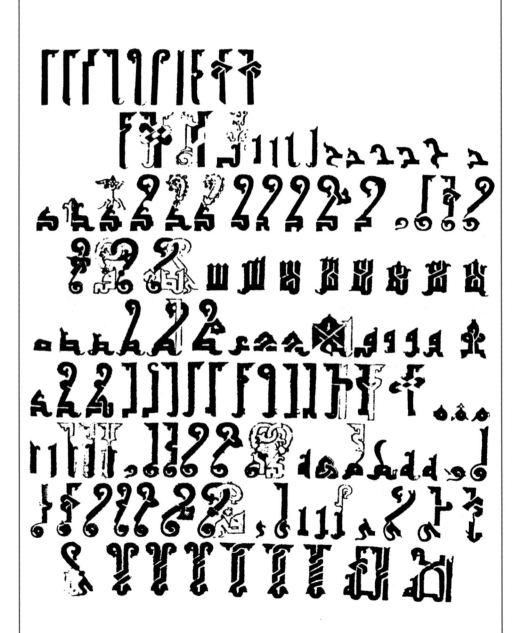

Carved Kufic (Iraq, twelfth century).

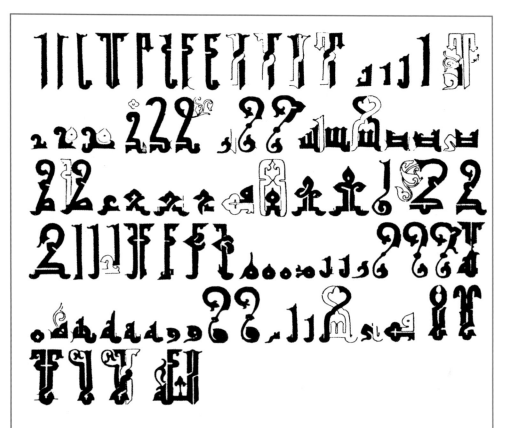

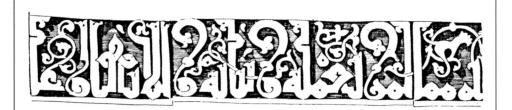

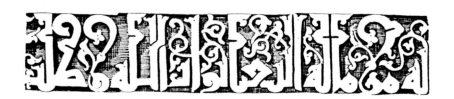

Carved Kufic (Iraq, 1102).

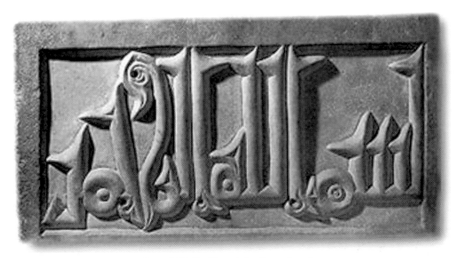

Carved Kufic (Egypt, tenth century).

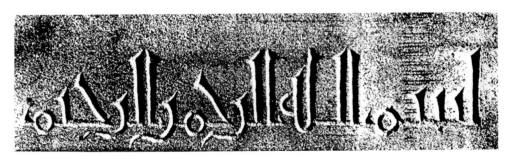

Engraved Kufic (Egypt, 966 CE).

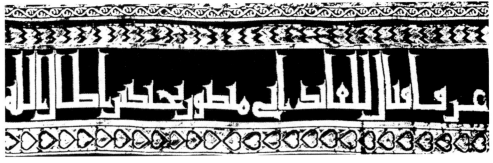

Classic woven Kufic (Persia, tenth century).

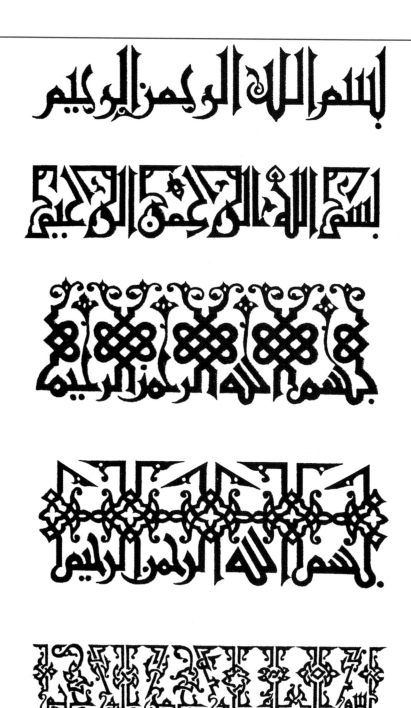

From classic to baroque: the same phrase with increasingly ornate decorative endings.

After this period of balanced classicism there followed one in which writing was fully exploited for decorative purposes, even to the extent of overloading, in a style that could almost be described as baroque. Nevertheless, despite the abundance of decoration, most of the time the writing remained very legible.

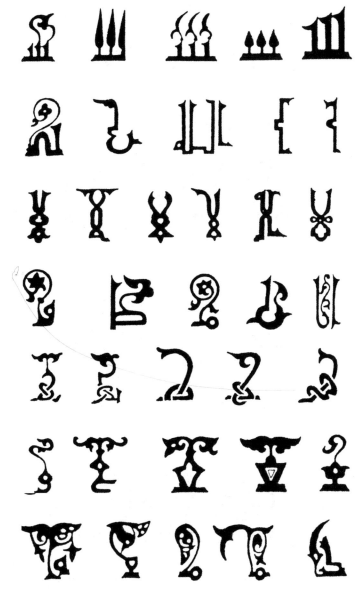

Some of the countless variations of Kufic decorative endings.

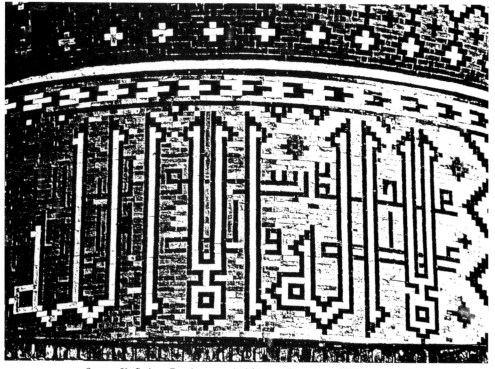

Square Kufic in a Persian mosaic (thirteenth century, Nishapur, Iran).

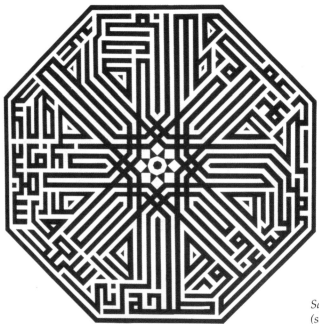

*Square Kufic
(seventeenth century, Cairo).*

The Quadrangular Style

The Kufic script attained its ultimate geometrical style when transposed onto mosaic. All curves were removed and the result was the square, geometric Kufic style.

The graphic potential of this style was mostly developed for monumental inscriptions.

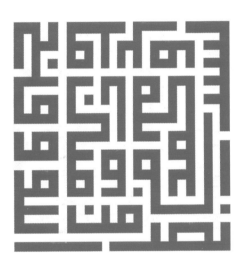

Square Kufic to be read in spiral fashion (mosaic, Iran).

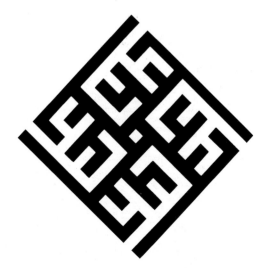

Square Kufic in mosaics. Here the name 'Ali is repeated at several angles and may be read in black or white (Iran).

The Development
of Arabic Writing

A major event that considerably influenced the style of Arabic writing was the invention of paper by the Chinese in 105 CE and the subsequent discovery of it by the Arabs in Samarqand in 751 during their westward expansion.

Paper was both easy to make and relatively cheap, and accelerated the spread of writing. The smooth surface of this new medium profoundly changed Arabic writing and led to the further development of cursive styles, thus paving the way for the golden age of Arabic calligraphy.

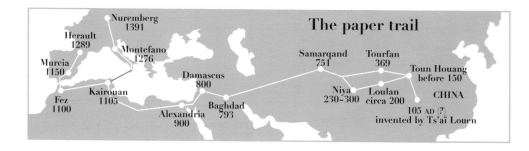

The paper trail

Nuremberg 1391
Herault 1289
Montefano 1276
Murcia 1150
Damascus 800
Samarqand 751
Tourfan 369
Toun Houang before 150
Fez 1100
Kairouan 1105
Baghdad 793
Alexandria 900
Niya 230–300
Loulan circa 200
CHINA
105 AD (?)
invented by Ts'aï Louen

The production of paper followed the development of the major university towns.

In around 1200, there were more than 300 paper manufacturers in Fez, and part of their output was sold to the Christian world.

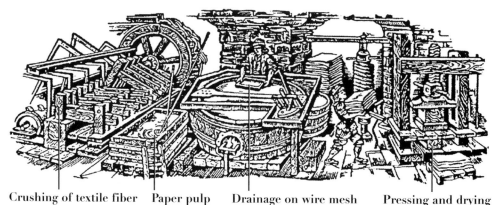

Crushing of textile fiber Paper pulp Drainage on wire mesh Pressing and drying

Paper manufacturing in Europe in the fifteenth century.

The Expansion of
the Muslim World

The practice of writing spread with the expansion of the Arabian empire. The active dissemination of the Qur'an led to the establishment of numerous universities. Moreover, the administration of territories that were increasingly distant from their capitals further increased the need for written communication.

This increased production of written texts encouraged the development of cursive writing styles that rapidly replaced Kufic, which was considered too slow and was relegated to headings. During the blossoming of calligraphy, the Kufic style almost disappeared from manuscripts but continued to be used primarily for monumental and decorative inscriptions.

Naskh writing before Ibn Muqla's codification.

The most common variations.

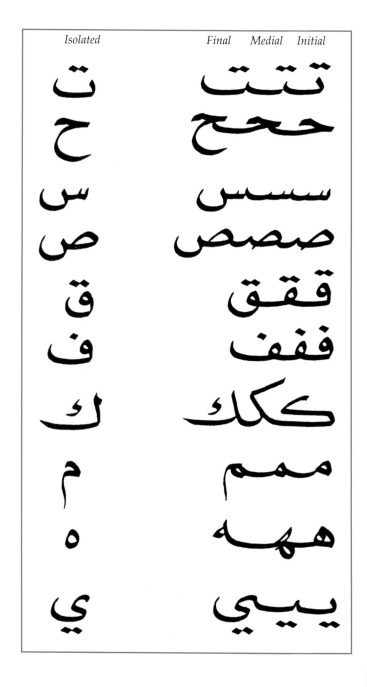

Isolated		Final	Medial	Initial

Calligraphic
Strokes and Flow

Writing is the trace left by the movement of the pen. With the invention of paper and improved ways of sharpening the extremity of reed pen, the hand was freed from the linear constraints of carved lettering. The supple and continuous movement of the pen contributed to developing curves. The calligrapher wrote for as long as possible before lifting his pen. In this way he achieved a pure, uninterrupted flow of movement, and also gained time. The result was the formation of specific shapes for each letter depending on the letter that preceded or followed it.

Thus with use, each letter of the Arabic alphabet acquired between one and four distinct shapes, depending on where it was situated in a word. Moreover (and for the same reasons), combinations of several letters gave rise to special graphic shapes called ligatures, which were faster to write and followed the logical movement of the writing implement.

Final letters developed large curved appendices that filled the space between words and also served as a harmonious introduction to subsequent ones.

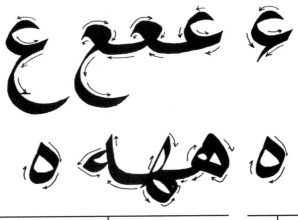

Derivative forms obtained
by uninterrupted cursive movement

Original
form

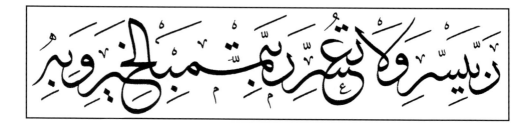

<p dir="rtl">ن يسر ولا تعريبت من بل الخير ويه</p>

<p dir="rtl">أعوذ بالله السميع العليم من الشيطان الرجيم</p>

<p dir="rtl">الاب ب س ح ح ح ح ح ح حلد حرد د ند ند</p>

<p dir="rtl">ر د د مر و وس س س ش خ حس حسه</p>

<p dir="rtl">ص ص ص ط طا ط نط طه طر طا ع</p>

<p dir="rtl">ع عا عد بلع بلعا بلعه عدبع فن فن ف</p>

<p dir="rtl">ق و بو ك ك لك لك كا مكلف مكلوكسه</p>

The shapes of letters multiplied as they were adapted to each new configuration
according to the calligrapher's skill and imagination.

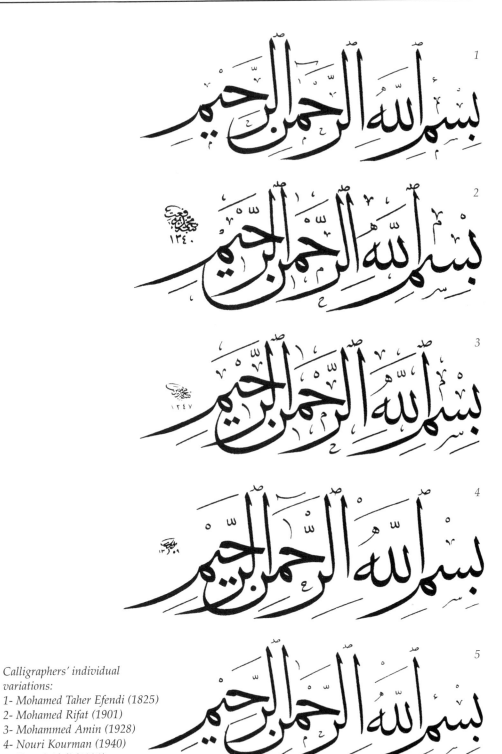

Calligraphers' individual variations:
1- Mohamed Taher Efendi (1825)
2- Mohamed Rifat (1901)
3- Mohammed Amin (1928)
4- Nouri Kourman (1940)
5- Kamel Akdi (1931)

Pages from the Canon of Calligraphy *transcribed by Muhammad al-Shaf'i (Egypt, 1663).*
Note the copyist's comments in the margins.

Ibn Muqla's Canon
of Calligraphy

Ibn Muqla (894–950) was the first person to codify the writing that became known as *naskh*, by laying down the forms and proportions of each letter. In his *Canon of Calligraphy* he specified that the height of the alif was to be taken as the diameter measurement of the circle to be inscribed around each letter.

The standardization of elements that were common to several letters established a graphic unity while leaving considerable freedom to the calligrapher.

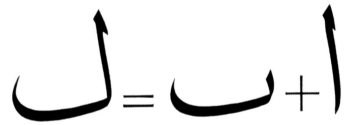

Ibn Muqla also analyzed each movement of the reed pen and named them:

| vertical | oblique | arched | horizontal | extended |

In addition, Ibn Muqla provided advice on making ink and sharpening the reed pen. He may have been the first person to cut the reed at an angle.

Pages from the Canon of Calligraphy *copied by Muhammad al-Shafi'i in 1663* CE. *The letters with measuring points were added by the copyist (Egypt).*

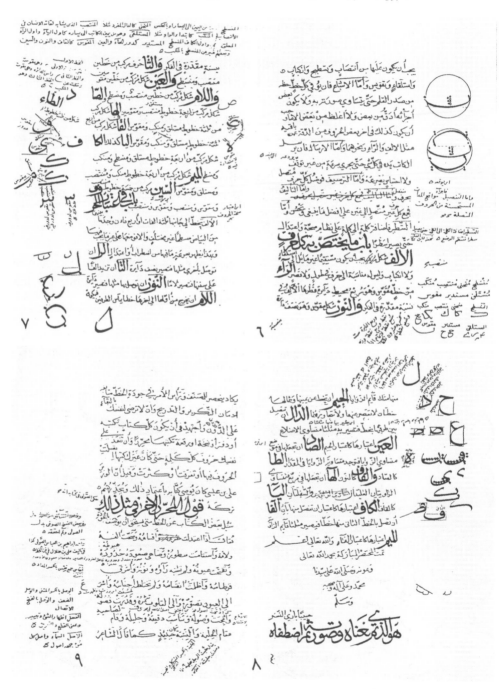

The perfect elegance of Ibn Muqla's *naskh* writing and the beauty of the line drawn by the reed pen made this style the one most frequently used scripts up to the present, and is still the basis for artistic expression in the Muslim world today.

The roundness of *naskh* lines and the rhythm of their spacing made it the natural corollary oral culture. Just as the listener can feel the emotional vibrations of an orator's voice, so the reader of a *naskh* manuscript can be aware of the minute sensitive impulses of the calligrapher's hand. Every breath is perceptible.

Other calligraphers followed Ibn Muqla and perfected his basic rules.

Following Ibn Muqla's principles, the proportions begin from a circle in thuluth script (tenth century).

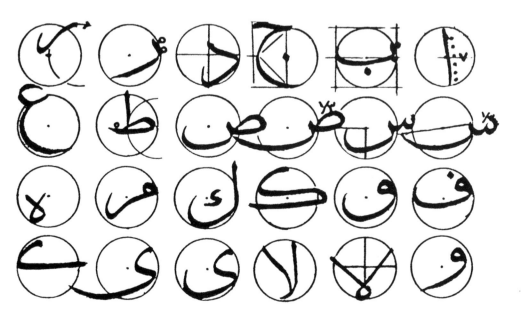

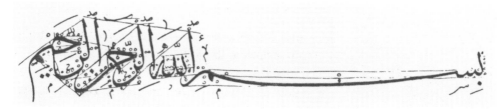

The proportions as applied to a Qur'anic inscription.

top
هَامَتهَا

forehead جَبِينهَا
front قَدَامهَا
stomach بَطنهَا
waist خَاصرتها
knee رُكبَتها
below the knee تَحت رُكبَتها

قفَاها back
خَاصرتها waist

تَحتها
bottom

*The parts of the letter alif
described using parts
of the human anatomy.
Extract from a book
by Abu 'Umar al-Dani (1052).*

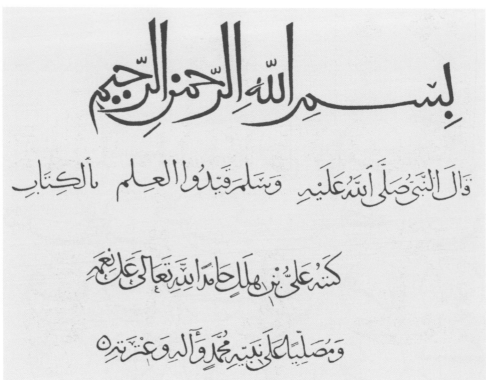

Thuluth style calligraphy by Ibn al-Bawwab (1022).

The Standardization
of Cursive Writing

Many calligraphers were to perfect Ibn Muqla's method, including Ibn al-Bawwab (1022), Abu 'Umar al-Dani (1052), Yaqut al-Musta Simi (1298), Shaykh Hammidallah Hamasi (1520), and Hafiz 'Uthman (1698).

One of the most important innovations was the use of the measuring point. Calligraphers needed a unit of measurement to specify sizes and proportion, and the unit chosen was a rhomboid point, the sides of which were equal to the width of the nib of the pen, which in turn varied according to the angle at which the reed was cut.

This is not a very precise unit of measurement but it does allow individual calligraphers to respect established proportions in their own interpretations. This traditional method is still in use today.

A different width of reed pen for each letter height.

| Naskh | Riqa' | Diwani | Ta'liq |

The measuring point system applied to different styles.

The Angle
of the Nib

The careful sharpening of the stylus or reed pen determines the thickness of the stroke and the style of writing. Each style and every letter height requires a specific pen.

Technically, the various calligraphic styles are determined by:

• the width of the reed,
• the angle of the nib,
• the chosen height of the letter *alif*,
• the chosen angle of the vertical stroke of the letter *alif*,
• the chosen angle of the line of writing,
• the broadness of the stroke, determines the spaces between the words.

Cut of the nib for the Maghribi script.

Cut of the nib for the riqa', ta'liq, and eastern Kufic scripts.

Cut of the nib for the naskh, thuluth, ijaza, and diwani scripts.

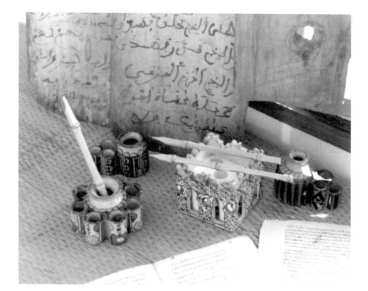

Inkwells, reed pen, manuscripts, practice boards (Morocco).

Classic Cursive Scripts

Six styles of cursive writing, known as *al-Aqlam al-Sitta* (The Six Pens), were codified by master calligraphers and deemed worthy of being used for transcribing the Qur'an. These were: *naskh, thuluth, muhaqqaq, tawqi, riqa',* and *rihani.*

Naskh

Although the *naskh* style was one of the earliest cursive styles, it became truly popular only after Ibn Muqla's Canon. Ibn al-Bawwab then perfected this style of writing and because of its elegance and readability, as well as its relative ease of use, *naskh* remains the most widely used style to this day.

Thuluth

The name actually means 'one-third,' possibly because this writing was one-third of the size of *tumar*, the widely used Kufic script. Alternatively, it may have been named for the proportions between the straight lines and the curves. The rounded and slightly emphatic style of its generous curves made it especially suitable for ornamental styles in titles, chapter headings, and dedications.

Muhaqqaq

Like *naskh* and *thuluth*, the *muhaqqaq* style was standardized by Ibn Muqla and perfected by Ibn al-Bawwab.

Tawqi

A similar style to *thuluth, tawqi* was created in the ninth century and adopted by the Abbasid Caliphate as the royal script. This prestigious use gave rise to variations of the letter combinations called ligatures.

Riqa'

Riqa' is very close to *tawqi*, but rounder and with a tendency toward simplification.

Rihani

This style emerged in the ninth century and shares characteristics with *naskh, thuluth,* and *muhaqqaq*. The curves under the line of writing are lively and slightly slanted.

Dozens of other styles also existed but were more or less short lived.

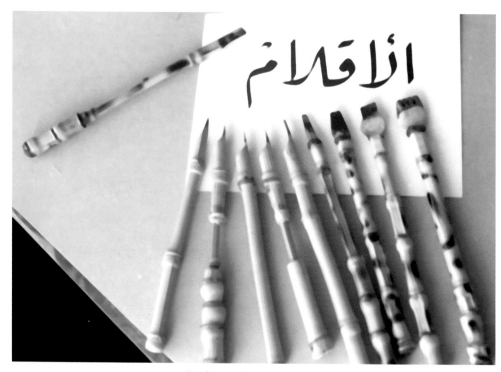

Reed pens of various widths.

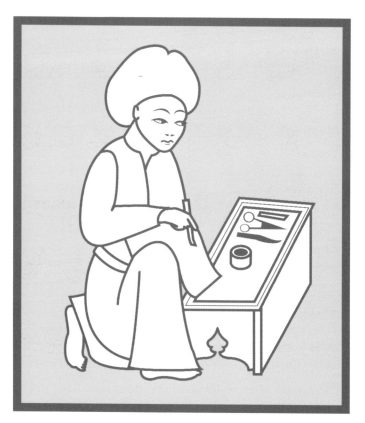

*The calligrapher
and his tools:
paper, reed pen, inkwell,
knife, scissors,
and whetting stone.*

Naskh script, sample by Hassan Massoudy.

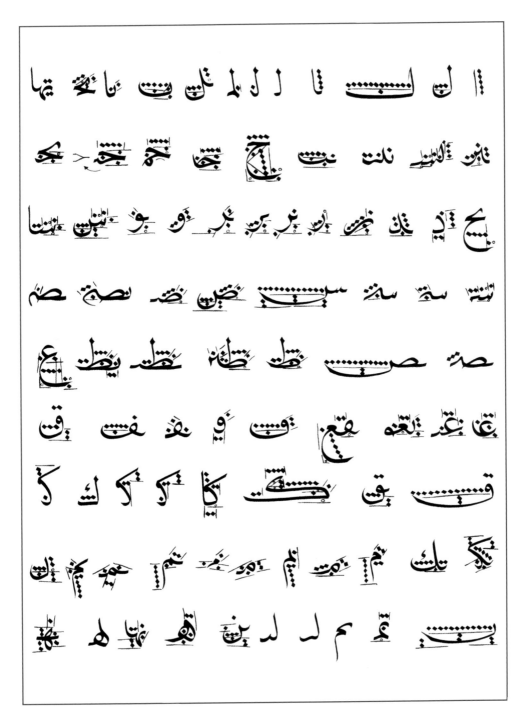

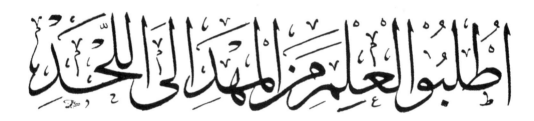

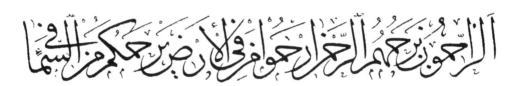

Thuluth script (Turkey, fifteenth–sixteenth centuries).

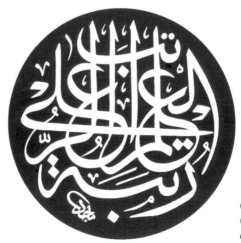

Calligram in thuluth script (Turkey, fifteenth–sixteenth centuries).

Thuluth script, sample by Hassan Massoudy.

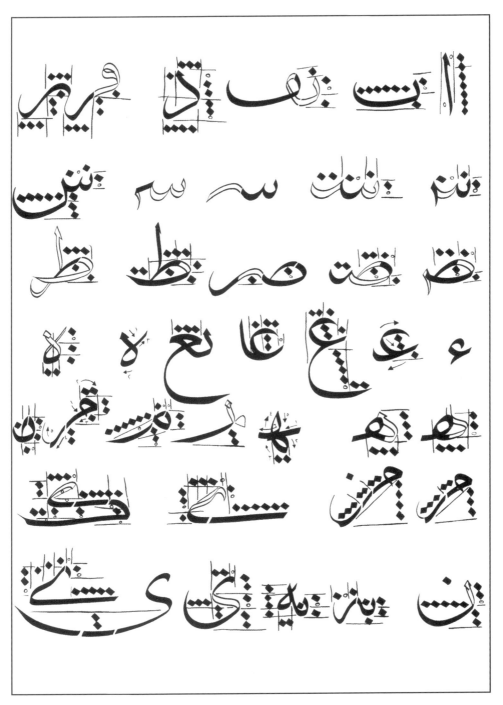

An example of the muhaqqaq style.

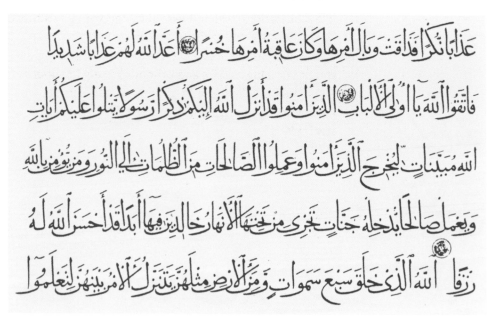

An example of the tawqi style.

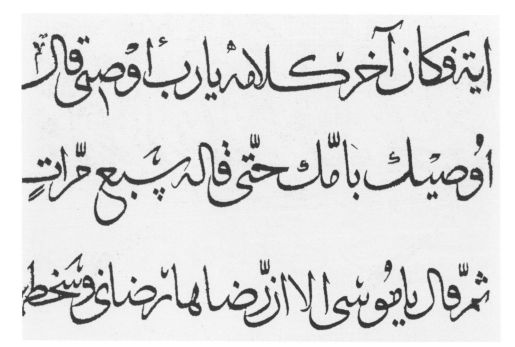

Arabic writing was influenced by the various cultures that were subjected to the Islamic conquest.

Two major influences gave rise to styles of writing that were to become classics and produced many offshoots:
- Ottoman influence produced *riqa'* and *diwani*
- Persian influence produced *ta'liq*, *nesta'liq*, and *shekasteh*.

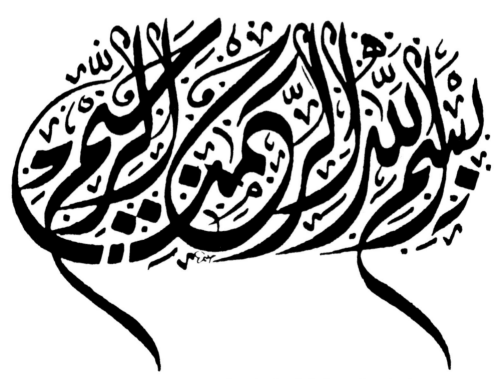

Graceful Ottoman diwani calligraphy (Istanbul, nineteenth century).

Riqa' style.

ىسى ى سى ى ل ا ل لى ثمت الحروف بعون الله الملك الرؤوف .

عليكم بحسن الخط فانه من مفاتيح الرزق

اكرموا اولادكم بالكتابة فان الكتابة من اهم الامور واعظم السرور

Diwani style.

ولا تمسك بعهد الذى اعجبت الاكم عيسك الماء الغزير

كانت مواعيد عرقوب لها مثلا وما مواعيدها الا الاباطيل

Diwani jeli style. Here the marks only serve to decorate empty spaces.

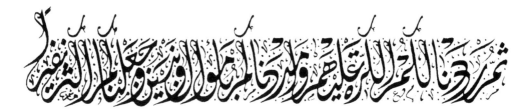

Ottoman

Cursives Scripts

Calligraphy developed considerably under the Ottoman Empire (1299–1923). Skilled Turkish calligraphers further perfected *naskh* and *thuluth* and introduced two styles of their own, *riqa'* and *diwani*.

Riqa'

Different of the classic script, this style was invented by Abu-l-Fadl Muhammad Ibn Khazin to facilitate administrative writing. It is characterized by an extreme economy of pen strokes and the removal of any gratuitous esthetic effect. The slant in every stroke is pronounced. Because it was quick and easy to use, this style became very popular, and it continues to be used a great deal today.

Diwani

The Diwani style was created for the exclusive use of the imperial court. It was first reserved for edicts and official decrees and was then used frequently in ornamental calligraphy. *Diwani jeli* is a decorative variation.

The special graphics used in the *Tughra*s, or imperial signatures, were directly inspired from *diwani*.

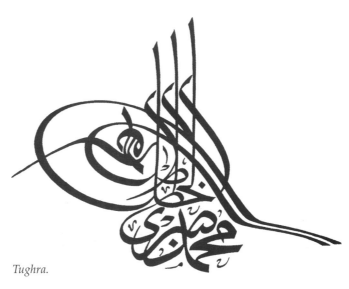

Tughra.

Riqa' script, sample by Hassan Massoudy.

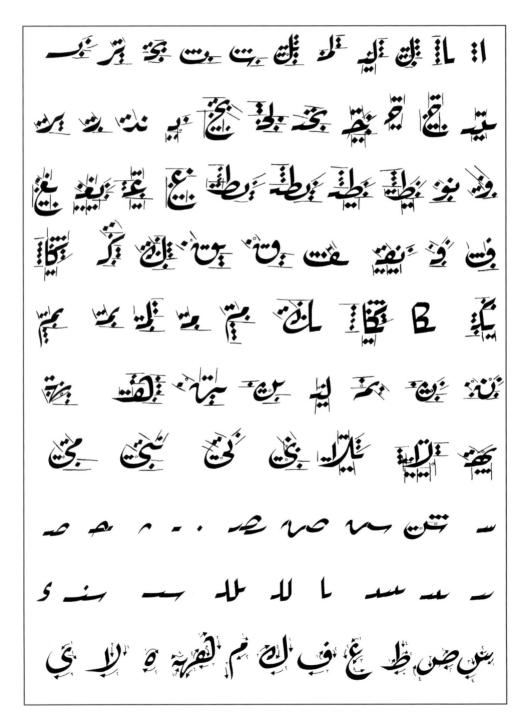

Diwani script, sample by Hassan Massoudy.

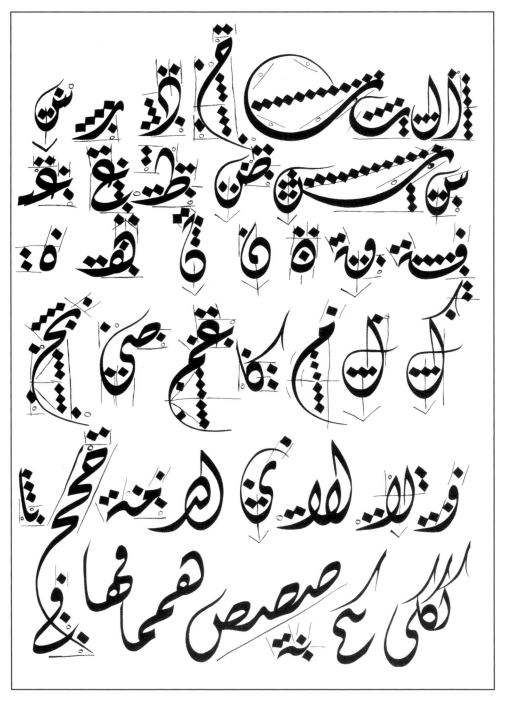

Ta'liq style.

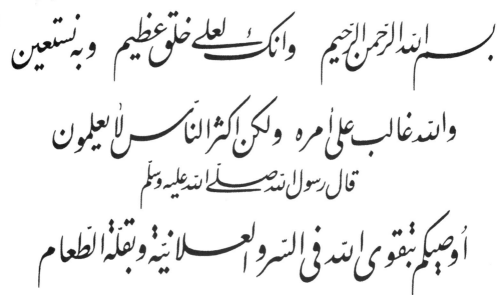

Shekasteh style (Persia, sixteenth century).

Persian Cursive Scripts

In the tenth century, Hajj Abu 'Ali, a disciple of Ibn al-Bawwab, succeeded in adapting the Arabic script to the Persian language and created *ta'liq* (also known as *farsi*), or 'hanging script.' Every word followed its own sloping line and all the lines were parallel.

Toward the end of the seventeenth century, Mir Ali of Tabriz, influenced by the *naskh* style, invented *nesta'liq*, or 'broken' writing.

Lastly, Abdoul Hefid Taleqani created the *shekasteh* style. The contrast between downward and upward strokes is considerable in all three styles. The extreme slants of the lines led to very full and original forms of layout.

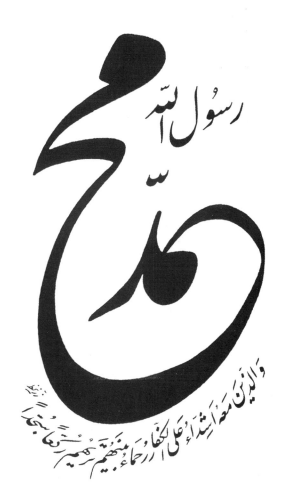

Elegant calligram in nesta'liq (Persia, sixteenth century).

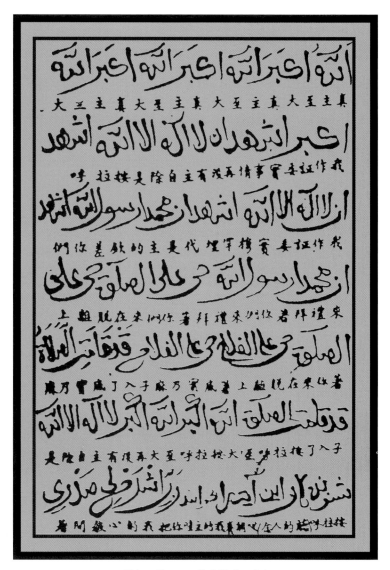

China, the so-called Sini script.

Indonesia. The graphic differences are due to the use of a brush instead of a reed pen.

Other

Influences

Locally, in India, Indonesia, China, and Africa, Arabic writing was subject to other lesser influences, but no really prominent style resulted.

These variations were mainly due to the different media and writing instruments used.

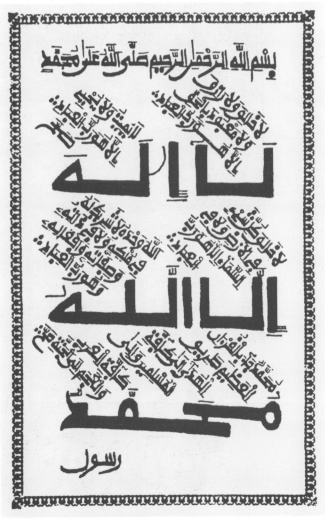

Sudani script (Nigeria).

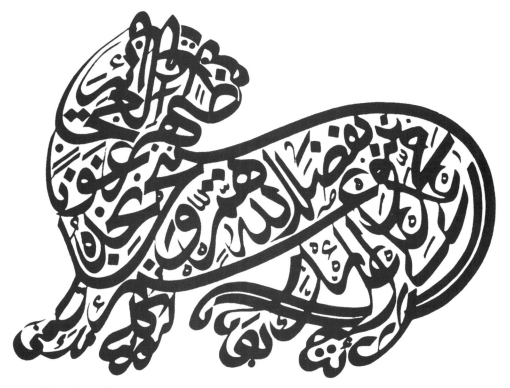

Figurative calligraphy in praise of Imam 'Ali, the 'Lion of God' (Persia, sixteenth century).

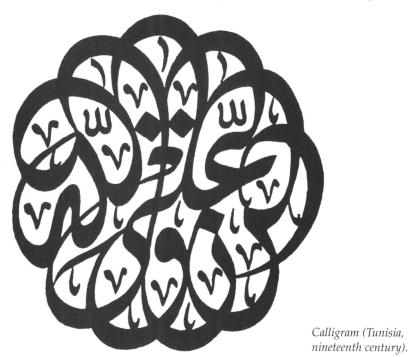

*Calligram (Tunisia,
nineteenth century).*

After many years of balanced and legible calligraphic styles came a period of increasingly stylized calligraphy, which was esthetically attractive but difficult to read. Calligraphy essentially became a decorative art, with calligraphers competing in manual prowess. Sometimes there was a deliberate attempt to reserve the meaning of the text for a religious or intellectual elite.

Because of the limitations imposed by Qur'anic law calligraphy was one of the few means of artistic expression, and calligraphers, like all artists, signed their works.

Calligram (Turkey, nineteenth century): esthetically beautiful but difficult to decipher for any but the initiated reader. The only purpose of the small accents is to balance the blank spaces.

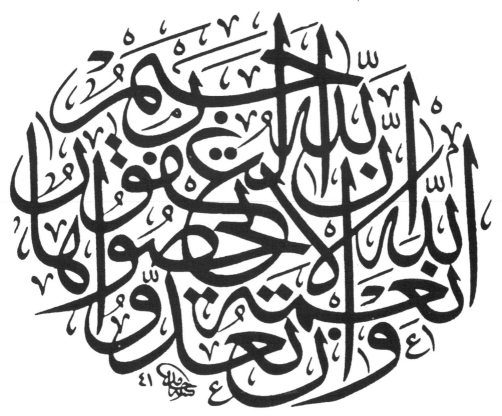

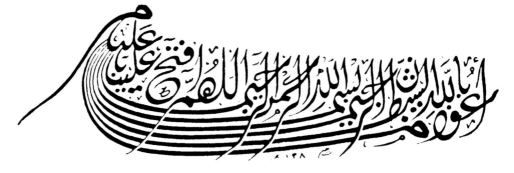

A famous Turkish calligram in diwani (nineteenth century).

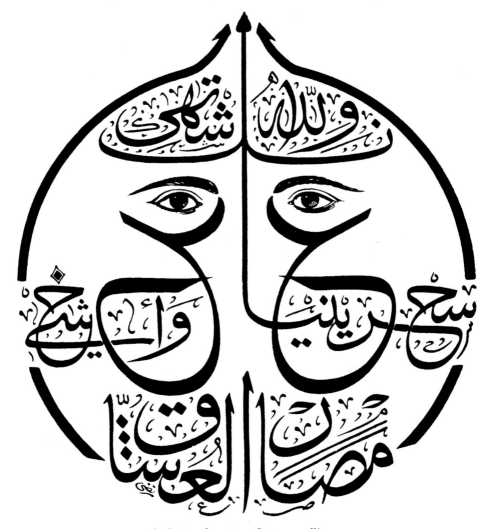

A nineteenth-century Ottoman calligram
with an unusual figurative representation of a pair of eyes.

The Sublimation
of Calligraphy

Traditional sacred respect for 'signs that speak' mingled with superstition, sometimes takes on a symbolic and mystical aspect.

For the Sufis, in particular, calligraphy was a medium for meditation. Thus the written medium for divine thought was itself 'inspired' to visualize the harmony of the message itself.

This religious attitude to writing remains an important factor in the cultural development of the Arab world.

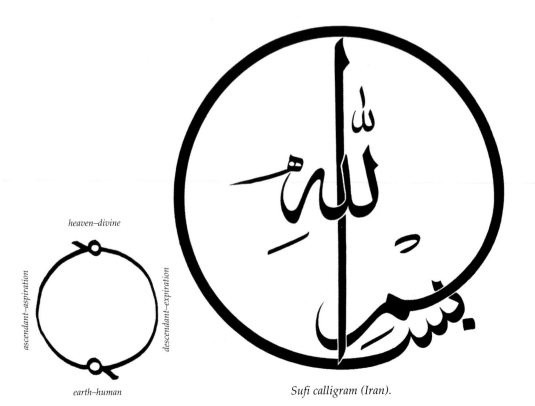

heaven–divine

ascendant–aspiration

descendant–expiration

earth–human

Sufi calligram (Iran).

1 2 3 4 5 6 7 8 9 0	**Origins**
	China
	India (Brahmi) 300 BCE
	India (Devanagari) second century
	India (Devanagari) ninth century
	Indes (Gwalior) thirteenth century

Eastern Arabic numerals

ninth century

tenth century

eleventh century

fourteenth century

North African Arabic numerals

North Africa, ninth century

Andalusia, eleventh century

North Africa, thirteenth century

Current numerals

Eastern Arabic numerals

Western numerals

France, fifteenth century

Europe, seventeenth century

1 2 3 4 5 6 7 8 9 0

twentieth century

From Indian to Arabic

The origin of the use of signs to represent numbers is blurred and has merged with the origin of writing, although numerals doubtless came first. Primitive marks (lines and dots) were used to count goods and individuals for a very long time.

Indian numerals

In the second century the Indians developed a system of notation for numbers with three major innovations:
• the decimal system;
• the use of different signs from those in the alphabet. They also had a different value according to where they were situated, and could signify a single unit, ten units, one hundred, or one thousand etc. according to the sequence in which they were written;
• the notation for zero, invented in around the sixth century.

Arabic numerals

During the Arab conquests and eastward expansion (Sindh, 710) the Arabs adopted the Indian system. Mastering numeric writing enabled them to make spectacular developments in mathematics and scientific research (tenth century). In the twelfth century, Europe adopted Arabic numerals via Andalusia in Spain, and gradually abandoned Roman numerals.

9	8	7	6	5	4	3	2	1
ط	ح	ز	و	ه	د	ج	ب	ا
90	80	70	60	50	40	30	20	10
ص	ف	ع	س	ن	م	ل	ك	ي
900	800	700	600	500	400	300	200	100
ظ	ض	ذ	خ	ث	ت	ش	ر	ق

Before Islam, the Arabs used various local ways of counting. With the emergence of Arabic writing it became commonplace to attribute a numerical value to each letter of the alphabet.

From Reed Pen
to Computer

After the blossoming of various calligraphic styles, artists in the Arab world continued to improve their calligraphic skills but ceased to make any further major innovations.

Nor did the meeting between the Arabic script and the printing press result in major graphic change. Engravers and type founders scrupulously respected existing styles, despite the technical difficulties that this represented.

It was only from the second half of the twentieth century that the need arose to adapt Arabic writing to modern means of communication and enable the Arabic language to access the most developed technologies.

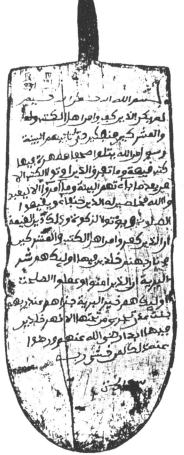

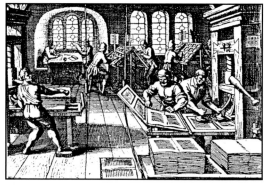

Left: a wooden board used to teach writing.
Above: a printing press in the fifteenth century.
Below: a computer room in the late 1980s.

The Origins
of Typography

Printing was invented in China in the ninth century. The process then used was xylography, or block printing using woodcuts, which meant carving out images or text (or both) in relief on pieces of wood. This technique was also used to print patterns on cloth.

In 1045 CE, Pi Sheng created mobile characters in baked clay. Later these were made from tin, wood, bronze, and other materials. Printing spread rapidly to Korea and Japan.

Paper, it should be remembered, had been manufactured in China since the second century CE. Toward the end of the tenth century Chinese scrolls were replaced by books composed of sheets of paper that were folded and bound together.

Curiously, the Arabs ignored xylography at the time of their conquests, although the process was known in Samarqand in the tenth century.

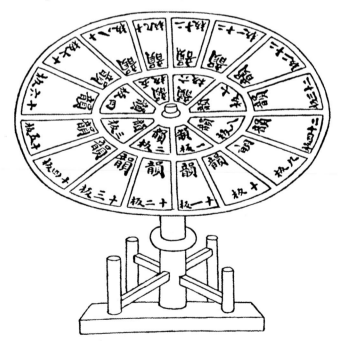

Pi Sheng built turning tables with compartments for storing his mobile characters. The typographer sat between two such tables and turned them to find the types he needed.

The first engraved and printed Arabic alphabet (Mainz, 1486).

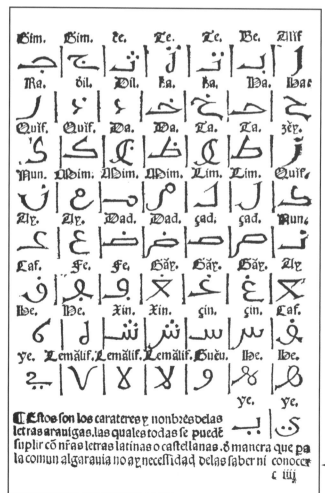

⁋ Estos son los carateres y nonbres delas letras arauigas. las quales todas se puedē suplir cō nr̄as letras latinas o castellanas. ó manera que pa la comun algarauia no ay necessidad delas saber ni conocer

c iiij

Arabica.

(Arabic text)

One of the first Arabic texts composed in movable types in Italy by Guistiniani in 1516.

—The first Arabic alphabet printed in Spain by Pedro de Alcala in 1505.

80

The Invention
of Printing

Woodblock printing (xylography) had existed in Europe since the twelfth century. With the invention of paper, all the elements came together for the reinvention of typography, which had already existed in China for centuries.

It was Gutenberg, a silversmith who made polished metal mirrors and engraved medals, who first had the idea of using a hard metal punch to create moulds forcasting type and thus created the first movable types in lead for the individual letters of the Latin alphabet (1450).

This innovation would lead to the rapid spread of learning, but Gutenberg's invention was not always well received. Since he had used the manuscript writing style of his period, he was accused of being a forger and his printed works of being 'artificial writing.'

Early printing in Arabic

The first printed Arabic alphabet was found in Mainz (Germany) in 1486, in an engraving that illustrated the account of a journey to Jerusalem.

Very often Christian missionaries (as in the Levant in 1482) or western diplomats (Constantinople in 1488) installed printing presses in Muslim countries.

After the Reconquest of Spain, the Catholic clergy printed religious texts in Arabic, starting in 1505, in order to convert the population back to Christianity (Pedro de Alcala). However, the first text to be composed with movable Arabic type was printed in 1514 by De Gregoiris in Fano (Italy).

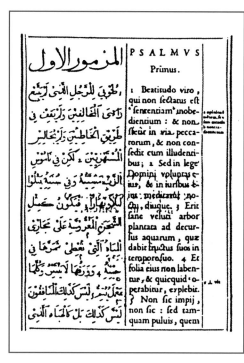

Composition in two alphabets: Psalms, Rome, 1514.

Al-Idrissi's Geography, Rome, 1592.

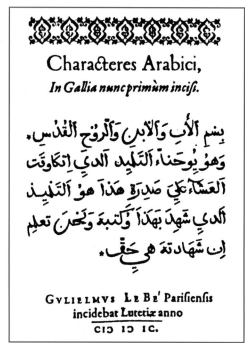

Arabic Letters, Guillaume Le Bé, Paris, 1598.

Text by Ibn Sina (Avicenna), Rome, 1593.

Early Printing
in Arabic

Religious rivalry with the Ottoman Empire as well as intellectual curiosity led the Vatican to print the Gospels and other religious texts in Arabic, in addition to dictionaries, and grammar and scientific works by authors such as Avicenna, who wrote in Arabic.

In 1608 the Propaganda Printing House was founded in Rome and, starting in 1613, created beautiful editions in Arabic. Famous engravers and type founders produced remarkable Arabic types for the major European universities, including Paris and London: Granjon (1550), Guillaume Le Bé (1620), and William Caslon (1730).

The beauty of the Arabic texts printed at this time is a reflection of the extensive work carried out by linguists, engravers, type founders, typographers, and printers, who had to overcome countless difficulties in their work. It took several years to typeset a book in Arabic.

The first printing presses in Arab countries

The first book to be typeset in an Arab country was printed in 1585 by the Maronite monks of Qozhaya (Lebanon).

In Morocco, the Portuguese set up a printing press in Fez in 1520, though no Arabic work was printed there before the end of the seventeenth century.

Printing only really took off in the various Arab countries from the eighteenth century—in Egypt (1799), as well as in cities such as Aleppo (1706), Jerusalem (1780), Kerbala (1856), Mosul (1860), Baghdad (1861), and Damascus (1870).

In the Ottoman Empire, the powerful guild of calligraphers successfully opposed the introduction of the printing press until the end of the nineteenth century.

MATTHEVS

بشارة يسوع المسيح كما كتب مار متي واحد من

Euangelium Iefu Chrifti quemadmodum fcripfit Mar Mattheus unus ex

اثني عشر من تلاميذه

duodecim difcipulis eius

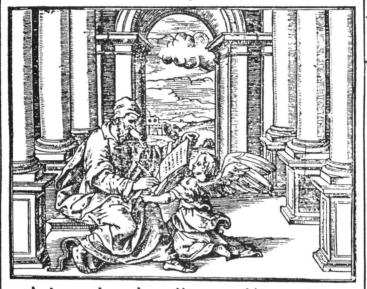

كتاب ميلاد يسوع المسيح ابن داود بن ابراهيم

Liber generationis Iefu Chrifti filii Dauid filii Abraham

فابراهيم ولد اسحق واسحق ولد يعقوب ويعقوب

Abraham genuit Ifaac. Ifaac autem genuit Iacob. Iacob autem

ولد يهوذا واخوته ويهوذا ولد فارص وزارح من ثامر

genuit Iudam, & fratres eius. Iudas autem genuit Phares & Zarah de Thamar.

وفارص ولد حصرون وحصرون ولد ارام وارام ولد

Phares autem genuit Efron. Efron autem genuit Aram. Aram autem genuit

عميناداب وعميناداب ولد نصون ونصون ولند

Aminadab. Aminadab autem genuit Naafon. Naafon autem genuit

Composition in two alphabets: Gospels (Rome, 1591).

بسم الاب والابن والروح القدس الاه وحده

تبدي بتاييد القدرة العالية نكتب كتاب المواعظ الشريفة

التي لابينا الجليل ـ فـ القديسين ـ اتاسوس بطريرك اورشليم

تقال في ايام الاحاد والاعياد السيد مر الى ذلك

احد الفصح المجيد

عظه لا بينا النبيل فى القديسين يوحنا فم الذهب بطرن ـ

مدينة القسطنطنطمة

من كان حسن العبادة ومحبا لله ٭ فليبقتح يحسن هذا المحفل البهج ٭
من كان عبدا شكورا ٭ فليدخل ـ فرح ربه مسرورا ٭ من تعب
صايما فليأخذ الان اجرته دينارا ٭ من عمل من الساعة الاولى ٭ فليعبل
اليوم حقه واجبا ٭ من قدم بعد الساعة الثالثه ٭ فليعيد شاكرا ٭
من وافا بعد الساعة السادسة فلا يشك فانه لا يخسر شيا ٭ من تخلف ـ
الساعة التاسعه ٭ فليتقدم غير مرتاب ٭ من لحق الساعة الحادية عشر
فقط ٭ فلا يخشا الابطاء ٭ لان السيد يحب ان يكرر ٭ يقبل
الاخر مثل الاول ٭ يريح صاحب الحادية عشر ٭ كالذي عمل من
الساعة الاولى ٭ فهو للاخر يرحم ٭ والاول يقتنع ٭ لذاك يعطى ٭
ولهذا يهب ٭ للعمل يقبل ٭ وللعزم يصافح ٭ يكرم الفعل ٭ ويمدح

Gospels printed in Arabic (Aleppo, 1711).

Kufic type: 181 characters in 14- and 44-point. Carved in 1806 by Renard.

Arabic type known as the 'Four Gospels' in 30-point naskh font, 356 characters.
Medici Printing Press in Rome, 1590.

Arabic Type and Letters from
the Imprimerie Nationale in Paris

Although Arabic is one of the longest-known oriental languages in Europe, it began to be studied scientifically only in the nineteenth century. Baron Silvestre de Sacy, a professor and later administrator of the Ecole des Langues Orientales, was one of the pioneers. This eminent linguist was also Inspector of Oriental Type at the Royal Printing Press and devoted himself to organizing the Arabic fonts of the state printing press.

As a result, the Imprimerie Nationale collection, which reflects the history of Arabic typography over nearly four centuries, is one of the best and most beautiful collections in the world. It includes, among other treasures, a number of Arabic punches and characters from the Medici Printing Press (Florence 1590) and the Propaganda Printing Press (Rome 1639).

يَكْتَنِفُهُ جَبَلَانِ شَرْقِيٌّ وَغَرْبِيٌّ

وَالشَّرْقِيُّ أَعْظَمُهُمَا يَبْتَدِئَانِ مِنْ

أَسْوَانَ وَيَتَقَارَبَانِ بِأْسْنَا حَتَّى

يَكَادَا يَتَمَاسَّانِ ثُمَّ يَنْفَرِجَانِ قَلِيلًا

قَلِيلًا وَكُلَّمَا آمْتَدَّا طُولًا إِنْفَرَجَا عَرْضًا

'Large Arabic,' 64-point naskh, 254 characters. Carved to order for Savary de Brèves, french ambassador to Constantinople from 1591 to 1605 and ambassador to Rome from 1608 to 1614. These fonts were used to print Napoleon Bonaparte's proclamations during his Egyptian campaign in 1798.

A typographer's case for traditional Arabic, without vowels, composed of 456 boxes. Note the large number of ligatures.

Technical
Difficulties

Since the cursive *naskh* style was the most commonly used form of writing Arabic, engravers and type founders faced very specific problems from the outset.

The numerous forms for each letter, depending on its place in a word, and the graphic combinations of certain groups of letters (ligatures) meant that a large number of typographic types was necessary.

The serious constraints of using lead resulted in the transformation of a lively handwritten style into a somewhat rigorous linear alignment, which further increased the problems of joining up the letters.

Because each consonant had to bear vowel marks or reduplication and orthographic signs, it took between 300 and 600 characters to compose text in Arabic, whereas a hundred or so sufficed for Latin script.

The result of having to manipulate this extremely large number of types was that manual typesetting took a long time and there was a greater risk of error, which had to be corrected. Furthermore, the fine lead types were fragile and did not hold up well to being constantly repositioned or to the wear-and-tear of printing. Lastly, the very small size of the empty spaces inside certain letters easily clogged up.

Letters with kerning. In order to combine certain signs (vowels or orthographic signs) some types had to fit into each other, making them difficult to handle (Berthold No. 49 font).

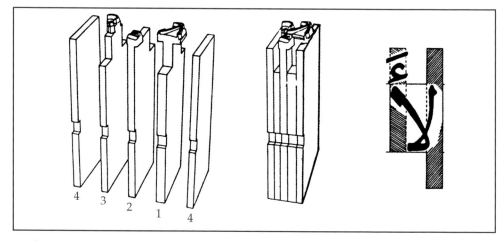

Mechanical composition (monotype).
1: the ligature lam-alif with cross-section; 2: vowel unit with kerning;
3: orthographic sign unit with kerning; 4: support unit with kerning.

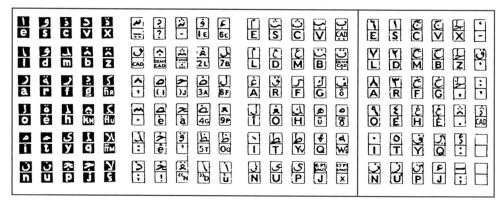

Linotype composition: main and auxiliary keyboard for composing simplified Arabic.

حروفاتنى ترتيب وتنضيد خصوصنده لسان ترکينك قارمه
قاريشيق والسنهٔ سائرهده بولنميان خروف مستقله و کلمهنك
ابتداسنده واورتهسنده وصوکنده ودها بشقه اشکالده
حروفاتى حاوى بر لسان بولنديغندن حرف نظرله بو لسانك
حروفاتنى کافهٔ اشکاليله لينوتايپ تسميه اولنان وحروفاتى

Linotype composition in 'Arabic old style' font.

Composition
Using Lead Typeface

As new methods of typesetting appeared they were adapted to Arabic writing. However, in order to respect traditional cursive writing styles, the manufacturers had to overcome a number of difficulties.

Manual typography
This is the oldest method of composition. For Arabic, the so-called Egyptian case was composed of between 300 and 450 boxes, excluding vowels.

Linotype
Mechanical composition was introduced in the nine-teenth century. A keyboard activated the setting of the matrices to compose a line of text. After the matrices were filled with liquid lead, a block was obtained for the equi-valent line of type. However, both the keyboard and the mechanics of this method were designed for the Latin alphabet, and the multitude of forms in Arabic writing required an additional keyboard. The accuracy with which the characters were joined up was even less precise than in manual typography.

Monotype
As with linotype, the characteristics of Arabic script required highly complex technological adaptations, with poor results.

'Simplified' Arabic
The large number of characters required for the mechani-cal composition of Arabic text led to the design of fonts known as 'simplified Arabic.' In most cases this meant reducing the letter shapes to two per letter: an initial–medial form and a final–isolated one.

There was also a fairly radical removal of vowel and orthographic signs, although some ligatures were kept.

So despite the rapid spread of printing in Arabic in the twentieth century, the cost and quality of the printed work were rarely satisfactory for either printer or reader.

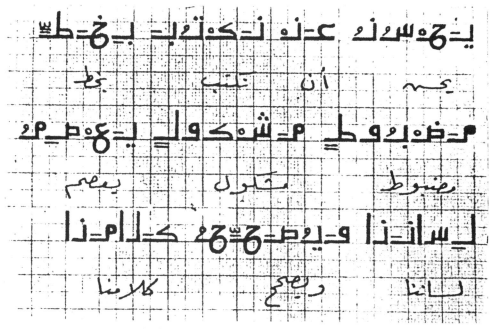

Ibrahim Muhammad Sadili's proposal (1948):
One sign per letter, vowels follow consonants, and a standard width.

Taysir Zubyan's proposal:
The letters are not joined, and the vowel signs are integrated.

Proposals for Reforming
the Arabic Script

From 1933, the need to adapt Arabic writing to the demands of the twentieth century led the Cairo Academy to launch a competition to find solutions that would be compatible with technology but still respect reading habits. The Academy's three guiding principles were:

• to reduce the number of signs in order to achieve a simple and economical way of typesetting and transmitting text by all available means;

• to include vowel and orthographic signs that would make full script Arabic easy to compose;

• to respect reading habits by maintaining the traditional written aspect as much as possible.

The Academy examined more than 250 proposals. Some focused on orthographic or grammatical simplification, others suggested graphic solutions that departed sharply from Arabic writing, even to the extent of using modified Latin letters. A few proposals suggested constructive solutions, but they were usually technically incomplete. In the end none of the proposals were approved by the Cairo Academy.

Some of the more serious
proposals:
1- M. Taymour
2- K.B. El Farag
3- M. Lakhdar-Ghazal
4- S. Ouaïda

1 هُـنَـيـهَـةٍ مِـنَ ألـتَـفْـكِـيـرِ

2 هُـنَـيـهـتِ مِـنَ التَـفْـكِـيـرِ

3 هُـنَـيـهَـةٍ مِـن التَـفْـكِـيـرِ

4 هُـنَـيـهَـةٍ مِنَ النَفْكِيرِ

'BTΘJHKDΔRZSŠ8ÐTŻ Ƹ G FQKLMNHWYAIU

'bt θ j ħ ӄ d ð r z š ꝣ d ţ ʒ ɛ ĝ ſ q k l m n h w y ɑ i u

'BƐƟJ ϒ ϔ DꝒRZꟙꟙ ꟙ DƐŻ Ƹ G F2KꟗMNHWYꟓIU

MISR al·Qâhira 'Iskandariyya Halab AL·MAƐREB

ɛala qadri 'ahli-l·ɛazmi ta'ti-l·ɛazâ'imu wa·ta'ti ɛala qadri-l·kirâmi-l·makârimu

wa·taɛzumu fi ɛayni-ꝣ·ꝣaĝîri ꝣiĝâruha wa·taꝣĝuru fi ɛayni-l·ɛazimi-l·ɛazâ'imu

'iðâ ħamala -l·ɛaqlu, naqaꝣat - iš·šahwatu. Baĝdad Ϗâlid

Ibrahim Muhammad Sadili's proposal (1948):
One sign per letter, vowels following consonants, 'Latinized' script

سورة الفائزة

لأبجديّة الموحّدة تسهّل الطباعة والتعليم

مصر سوريا لبنان العراق پاكستان

مصر سوريا لبنان العراق پاكستان

مصر سوريا لبنان العراق پاكستان

Nasri Hattar's proposal (1947–1956):
One shape per letter, no vowels, letters not joined up, adapted to several fonts.

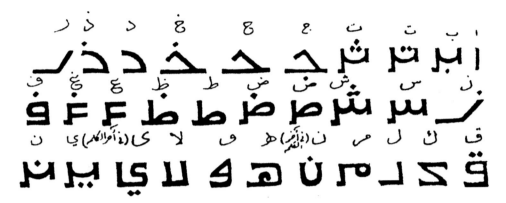

Muhammad Metwalli Badr's proposal (1947):
One shape per letter, no vowels, letters not joined.

فهتف نبيل للحال لأن ّ هناك
عدّة كميرات تماما كما تقول
يا نبيل فهذه الوسيلة تسمح

Roberto Hamm's proposal (1978):
One or two forms per letter, a 'letter joiner' that can take vowel signs, extreme standardization.

Letters superposed to show their standardization. The section in black highlights the role
of the 'letter joiner,' which is treated as a character and can take vowel and orthographic signs.

The Lakhdar
System

One of the proposals submitted to the Cairo Academy did bear fruit, thanks to help from UNESCO and the Arabic League Educational, Cultural and Scientific Organization (ALECSO).

Mohammed Lakhdar-Ghazal, a Moroccan linguist, presented his proposal in 1958. He was well aware of previous research as well as the technological constraints, and he created Standard Voweled Arabic, known as the Lakhdar system, which had the great advantage of being adaptable to all forms of typesetting and text transmission. This system finally enabled calligraphic writing styles to be transformed into printed letters.

The Institute for Study and Research for Arabization (I.E.R.A.) in Rabat, Morocco, worked for nearly 15 years to adapt the Lakhdar system to printing, typing, and computing, since this required the creation of several styles of lettering and the training of font designers.

Despite the relevance of the system, the quality of the work carried out, the cooperation between numerous type founders and manufacturers, not to mention the agreement in principle of several Arab countries, the project ran against the quasi-religious attachment of the Arab world to its traditional writing, and a general lack of political will to promote access to reading and knowledge.

Thanks to King Hassan II, who personally supported the project, only Morocco truly benefited from this work, and the system was used for newspapers, schoolbooks, and road signs.

One letter, one shape, one type

In order to reduce the number of types in a logical manner, each letter was given only a single shape, whatever its position in the word, thereby eliminating all variations that were not absolutely essential to reading.

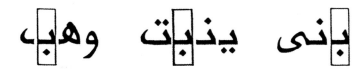

Final letters

A separate appendix was added to letter type in a final position, and three of these were deemed sufficient:

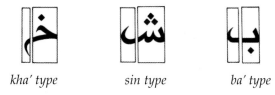

| *kha' type* | *sin type* | *ba' type* |

Complete vowel system

The traditional notation for vowels placed them above the consonants, obliging the reader to read at several levels. The Lakhdar system placed the vowel immediately after the consonant and made it possible to typeset and to read in a linear fashion.

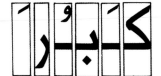

Every vowel sign has two forms:
• above or below the carrier for connected letters
• between two unconnected letters without the carrier.

The basic alphanumeric system: 84 characters

Including numbers and punctuation marks, this basic system enabled Arabic to be written with only 84 characters. It could be used when the equipment (for instance, mechanical machines with keyboards) allowed for only a limited number of types.

Complementary signs

Although it was entirely possible to read text printed with only 84 characters, the technical constraints involved in making the letter altered the esthetics of certain characters, especially the final ones formed with the appendices. Since most composition techniques did allow for the use of between 100 and 120 characters, a certain number of aesthetic letters were added to improve the resemblance to traditional writing:

Primary esthetic letters

Secondary esthetic letters

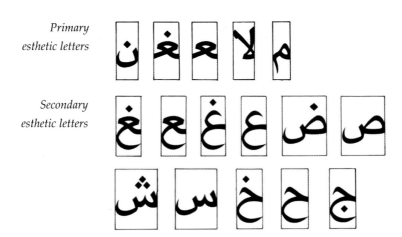

Standardized shapes

• all the letters were connected on the same horizontal baseline;

• the same baseline grid was used for all characters above or below the line of writing, for the thickness of the strokes, and for the angle of the vertical lines.

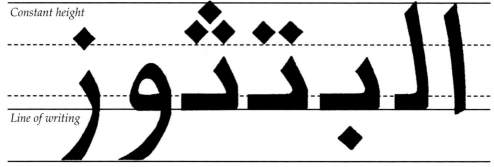

Constant height

Line of writing

Constant depth

The full alphanumeric set: 108 types

The full alphabet, including vowel signs, esthetic letters, special foreign letters, numbers, and punctuation formed a 108-character alphanumeric set that was compatible with all keyboards (the Latin alphanumeric set is composed of between 100 and 120 characters).

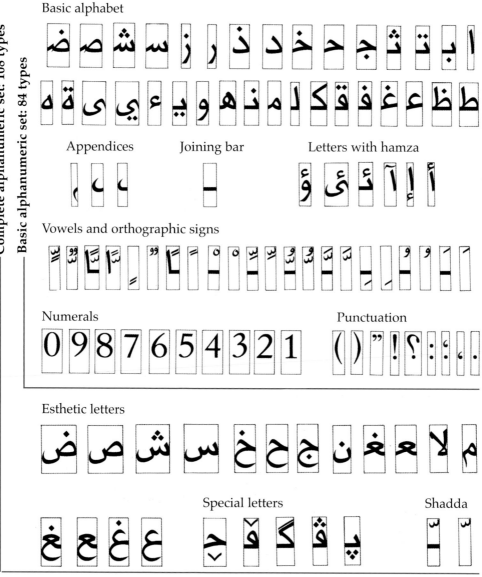

Naskh medium

إن محارف طريقـة العربيـة المعياريــة
المشكولة (العَمَمَـشَع) قد صممت على

Naskh light

إن محـارف طريقـة العربيـة المعياريـة
المشكولة (الَعَمَمـشَع) قد صممت على

Riqa' bold

تشد الرحال في نفس الوقت
فيقضي الناس بجوار المسجد

Riqa' medium

تشد الرحال في نفس الوقت فيقضي
الناس بجوار المسجد زمنا يؤدون

Riqa' light

تشد الرحال في نفس الوقت فيقضي
الناس بجوار المسجد زمنا يؤدون ـه

Kufic medium

تشد الرحال وقت الحج فيقضي الحجاج
يؤدون به الصلاة فإذا قدر لك أن تذهب

Typographic letters.

Typographic case SVA.

Standardized ISONORM 3098 B industrial script. Can be reduced for microfilm.

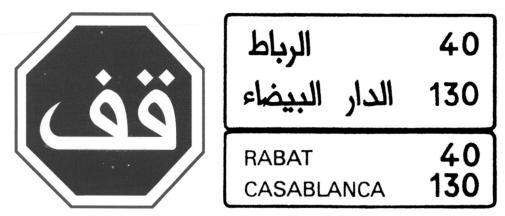

الرباط 40

الدار البيضاء 130

RABAT 40

CASABLANCA 130

Greater visibility in road signs and place names.

العلم نور والجهل ظلام *Thuluth*

العلم نور والجهل ظلام *Naskh*

العلم نور والجهل ظلام *Al Harf al Jadid 1*

العلم نور والجهل ظلام *Al Harf al Jadid 2*

العلم نور والجهل ظلام *Ahmed*

العلم نور والجهل ظلام *Central*

العلم نور والجهل ظلام *Huda*

العلم نور والجهل ظلام *Tahir*

العلم نور والجهل ظلام *Nasim medium*

العلم نور والجهل ظلام *Nasim bold*

العلم نور والجهل ظلام *Anti*

العلم نور والجهل ظلام *Mafid Mahdi*

العلم نور والجهل ظلام *Qasbah*

العلم نور والجهل ظلام *Salim*

العلم نور والجهل ظلام *Ziba*

العلم نور والجهل ظلام *Sangueen*

العلم نور والجهل ظلام *Kufic light*

العلم نور والجهل ظلام *Kufic medium*

العلم نور والجهل ظلام *Kufic bold*

Arabic in the Computer Age

In the 1990s, the invention and rapid spread of micro-chips and personal computers made research into adapting Arabic writing to printing and computing partly obsolete.

Now a single key per letter was sufficient, since the software program selected the shape of each letter according to its position in the word, with or without a vowel sign. Freed of material constraints, virtual fonts could recreate all the traditional forms of writing with a precision and quality that had been previously impossible.

In addition, graphic and multimedia software provided new dimensions for creating headlines and logotype through the large possibilities of distortion, colors, and textures.

This has undoubtedly been the greatest revolution for Arabic writing since the invention of paper. The question is, will this influence its shape and will new styles emerge as a result? At present this still seems unlikely, since the 'modern' attempts we see on advertising hoardings and on television are far from convincing.

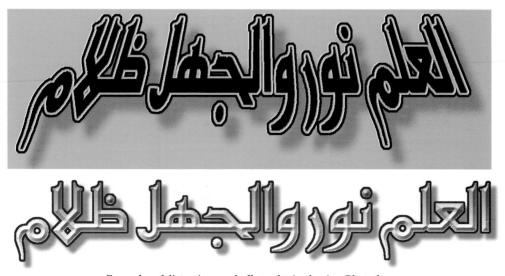

Examples of distortions and effects obtained using Photoshop.

نظام جديد للكتابة العربية
المطبوعة

An elegant font created by
Sabry Mohamad Higazy (Tunisia, 1981).

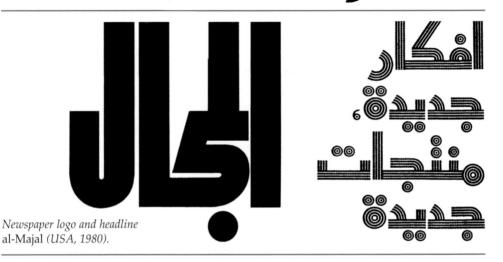

الأجيال

Newspaper logo and headline
al-Majal *(USA, 1980).*

الوطن العربي

Newspaper logo and headline
al-Watan al-Arabi *(Egypt, 2007).*

اقتصاد

Newspaper logo
Amwal *(Egypt, 2007).*

أموال

Contemporary Challenges
to Arabic Writing

Visibility

With the emergence of modern communication techniques, writing has to adapt to different requirements. The proliferation of media has changed reading habits and brought about new writing functions.

Mass media require rapid reading, often from a distance, which makes it vital to improve the visibility and legibility of texts in newspaper and magazine headlines, advertising and packaging, television and Internet, road signs and place names.

Bi-alphabetic texts

In texts with both Arabic writing and a translation using Latin script, the Arabic text is generally less visible than the Latin letters, though occupying the same area. This is due to the greater space between the lines and the unequal height of the letters, which give rise to empty spaces.

New Arabic scripts

It is mainly in the field of advertising that graphic artists try to improve the visual impact of Arabic, often inspired by monumental Kufic stone inscriptions. Unfortunately, many of these new designs reveal a lack of understanding of the deeper structures of Arabic writing and of type design. So-called 'fantasy' characters for fashionable graphics are often clumsy imitations of modern Latin letters.

To advance beyond this ambiguous stage, the graphic designer using Arabic must have an in-depth knowledge of the structure and styles of Arabic writing and extract the elements best suited to the desired type or logo.

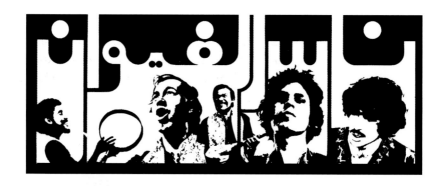

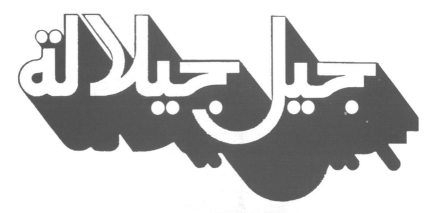

HOTEL ✶✶✶✶
MARRAKECH

Some designs by the author (Morocco, 1975–85).
From top to bottom: logo for Nas al-Ghiwan (musical group),
logo for Jil Jilala (musical group), logo for a glue, logo for a hotel.

Artists are interested in exploring calligraphy and rediscovering it as a means of artistic expression. This may be where the twenty-first century Arabic scripts will emerge.

'Go and cure your dignity, in hell if need be! And refuse humiliation, even in paradise!'
(al-Mutanabbi, tenth century). Calligraphy by Hassan Massoudy, 1996.

Glossary

Typographic characters.

Cursive writing.

Lapidary script.

Angular script.

Leading of a type.

Alphanumeric: the set of letters, numbers and punctuations marks used in writing.

Character: piece of metal (or wood, or plastic) with an alphanumeric sign, punctuation mark, or any other element of a font for use in tcomposing and printing typographic text. By extension, name of signs for all systems of composition. A character is defined by:
- the name of its font,
- its thickness,
- the point size,

for instance: 16-point *naskh* semi-bold.

Compose(text): to prepare for printing by assembling and ordering the types required.

Cursive writing: writing made easily with ink on a smooth surface such as papyrus, parchment, or paper.

Font: an assortment or set of type or characters all of one style and size.

Lapidary: a script style originally carved on a hard material such as stone. On a smooth surface, the writing appears angular.

Leading: vertical measurement in type size corresponding to the space between two continuous lines of text. It is measured in points (6-point, 10-point, 12-point, etc.).

Papyrus: a paper-like medium for writing made out of the stalks of the papyrus plant.

Parchment: non-tanned, air-dried skin of lamb, sheep, or goats used as a medium for writing.

The stylus.

Typographic case.

Stylus: a piece of reed that is cut and sharpened, and when dipped in ink is used as a pen.

Type founder: the person who casts the metal type.

Typographic case: box with compartments in which types are stored.

Typography: printing technique. The drawing or letters to be printed are cast in reverse and in relief to take the ink, which is deposited under pressure on to the paper. By extension, anything to do with composition of texts using movable types.

Vellum: the skin of a stillborn calf, treated to form a finer and smoother medium for writing than parchment.

Weight: the thickness of a letter. The same letter may exist in several versions: light, medium, bold, etc.

Weight of a character.

Bibliography

The origins of writing

Druet R. and Grégoire H., *La civilisation de l'écriture*.
 Paris: Fayard, Dessain and Tolra, 1976.
Etiemble R., *L'écriture*. Paris: Gallimard, 1973.
Gelb I. J., *Pour une théorie de l'écriture*.
 Paris: Flammarion, 1973.

Arabic calligraphy

Abdelkebir Khatibi and Mohamed Sijelmassi,
 Art of Arabic Calligraphy.
 Paris: Editions du Chêne, 1976.
Abdelkebir Khatibi and Mohamed Sijelmassi,
 The Splendor of Islamic Calligraphy.
 London: Thames & Hudson, 2002
Aziza Mohamed, *La calligraphie arabe*. Tunis: STD, 1973.
Al-Baghadi Hachem M., *Code de la Calligraphie arabe*.
 Baghdad: Iraqi Department of Culture, 1961
Bakhtiar Laleh, *Le Soufisme*. Paris: Seuil, 1977.
Hamid Safadi Yasim, *Islamic calligraphy*.
 Paris: Editions du Chêne, 1978.
L'art du livre arabe: du manuscrit au livre d'artiste.
 Exhibition catalogue, Bibliothèque nationale de
France, 2001.
Massoudy Hassan, *Calligraphie arabe vivante*.
 Paris: Flammarion, 2001.
——, *Perfect Harmony: Sufi Poetry of Ibn Arabi*.
 Shambhala, 2002.
——, *Abécédaire de la calligraphie arabe*.
 Paris: Flammarion, 2002.
——, *Calligraphies d'amour*. Paris: Albin Michel, 2002.
——, *Calligraphies pour l'Homme*.
 Paris: Alternatives, 2003.
Zaïn al-Din Naji, *Musawwar al-khatt al-arabi*.
 Baghdad: Iraqi Department of Culture, 1968.
——, *Bada'i' al-khatt al-arabi*.
 Baghdad: Iraqi Department of Culture, 1972.

Arabic writing and the advent of printing

Aboussouan Camille, *Le livre et le Liban*.
 Paris: UNESCO-AGECOOP editions, 1982.
Hamm Roberto, *Pour une typographie arabe*.
 Paris : Éditions Sindbad, 1975.
Higazy Sabry Mohamad, *Arabic Writing and
 Communication*. Italy: OPAM, 1981.
Khan, Gabriel Mandel, *Arabic Script*.
 New York: Abbeville Press, 2000.
Lakhdar-Ghazal M., *Méthodologie pour une arabisation de
 niveau*. Rabat, Morocco: I.E.R.A., 1973.
——, *Le système ASV-CODAR*. Morocco: I.E.R.A., 1974.
Meynet Roland, *L'écriture arabe en question*.
 (Cairo Academy projects from 1938 to 1968),
 Beirut: Dar-el-Machreq, 1971.
Le Cabinet des poinçons. Paris: Imprimerie Nationale, 1963.

Type design and typography

Frutiger Adrian, *L'homme et ses signes*.
 Méolans-Revel: Atelier Perrousseaux, 1999.
——, *Type, sign, symbol*. Zurich: edition ABC, 1981
Munsch R. H., *L'écriture et son dessin*.
 Paris: Eyrolles, 1966.
Richaudeau François, *La lisibilité*.
 Paris: Éditions Retz, 1976.
Richaudeau F. and Dreyfus J., *La chose imprimée*.
 Paris: Éditions Retz, 1977.

Typography and writing, and Arabic calligraphy

www.planete-typographie.com
http://pagesperso-orange.fr/hassan.massoudy
http://people.umass.edu/mja/history.html
www.sakkal.com/artarabiccalligraphy.html
www.islamicart.com/main/calligraphy/origins.html

DATE DUE

7/15 #66521969 CBC	

GAYLORD PRINTED IN U.S.A.

Graphic design and page layout:
Stefan F. Moginet
www.a-graph.net

سطيفان